Latin American Art

at the Allen Memorial Art Museum

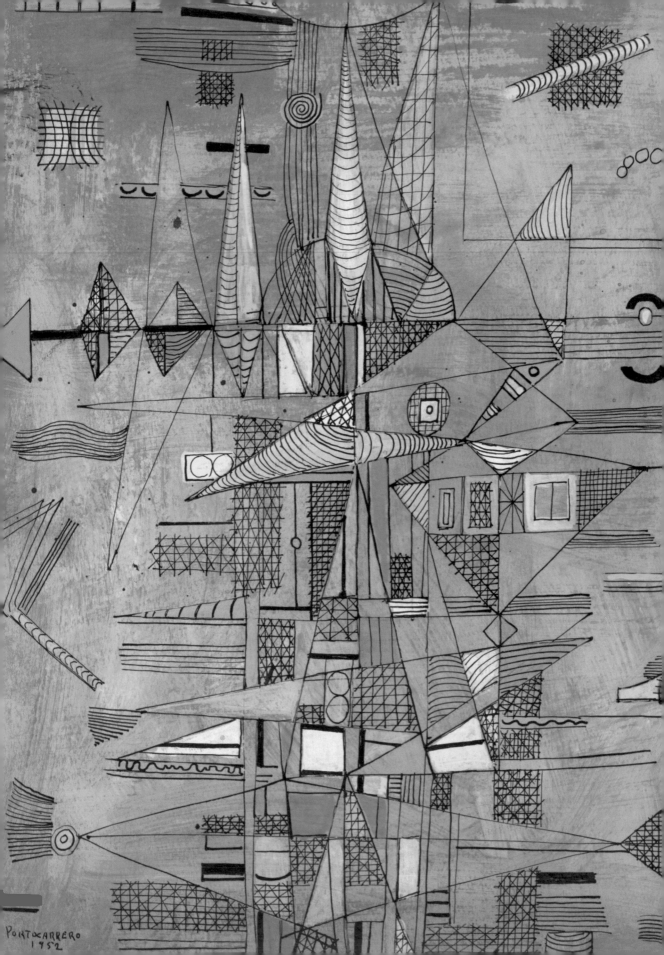

PORTOCARRERO
1952

Latin American Art

at the Allen Memorial Art Museum

Denise Birkhofer

with an essay by Steven S. Volk

Oberlin College, Oberlin, Ohio

Published on the occasion of the exhibition
Latin American and Latino Art at the Allen
ALLEN MEMORIAL ART MUSEUM
September 2, 2014, through June 28, 2015

Published by the Allen Memorial Art
Museum, Oberlin College
87 North Main Street
Oberlin, Ohio 44074
www.oberlin.edu/amam

Frontispiece: René Portocarrero, *Señales
No. 2* (detail), 1952, tempera and ink,
gift of Mr. Joseph Cantor, 1956.7. © René
Portocarrero

Page 26: Rimer Cardillo, *Untitled*, from
the series *Vanishing Tapestries*, 1996,
photo-silkscreen on canvas, gift of Cristina
Delgado (OC 1980) and Stephen F.
Olsen (OC 1979), 1997.37.4 © Rimer
Cardillo

Library of Congress Cataloging-in-Publication Data

Allen Memorial Art Museum.
 Latin American Art at the Allen Memorial Art
Museum / Denise Birkhofer; with an essay by
Steven S. Volk.
 pages cm
 Includes bibliographical references.
 ISBN 978-0-615-99720-9 (alk. paper)
 1. Art, Latin American — 20th century — Catalogs.
2. Art, Latin American — 21st century — Catalogs.
3. Art — Ohio — Oberlin — Catalogs. 4. Allen Memo-
rial Art Museum — Catalogs. I. Birkhofer, Denise.
II. Volk, Steven Saul, 1946– III. Title.
N6502.5.A45 2014
709.8'07477123 — dc23 2014013220

Produced by Marquand Books, Inc., Seattle
www.marquand.com

Megan A. Harding, Editor

Selina Bartlett, Photo Editor
Ryan Polich, Designer
Barbara Bowen, Proofreader
Typeset in Qubo and MetaPlus by Maggie Lee
Color management by iocolor, Seattle
Printed and bound in China by Artron Color Printing,
Co., Ltd.

Contents

Acknowledgments

The foresight, generosity, and dedication of many people have made this book possible. We wish first to thank the many donors who have contributed to the collection of Latin American art at the Allen Memorial Art Museum over the past eight decades. In addition to the earliest donors—Mrs. Malcolm L. McBride, Mr. Joseph Cantor, Leona E. Prasse, and the Print Club of Cleveland—we warmly recognize more recent supporters, including Thomas G. Campbell (OC 1955), Anne and Joel Ehrenkranz, Allan and Jean Frumkin, Ellen H. Johnson, Katharine Kuh, Anna Leithauser (OC 2002), Robert M. Light (OC 1950), Jerry M. Lindzon, Jack Lord, Norman and Jean Moore (OC 1938), Kenneth (OC 1967) and Nancy Schwartz, Mr. and Mrs. Paul Seligson, Edward J. Sullivan, César Trasobares, Kenneth and Barbara Watson, Esther S. Weissman, and Michael and Driek Zirinsky (OC 1964 and 1965). Particular gratitude is due to Cristina Delgado and Stephen F. Olsen (OC 1980 and 1979), who from 1995 to 2013 have made thirty-nine important gifts to the collection. Cristina's art-world expertise, connections, and advice have been invaluable assets in strengthening the museum's holdings. We also extend our gratitude to the many donors whose contributions to the museum have resulted in funds used to purchase Latin American works, among whom are the Horace W. Goldsmith Foundation, Charles F. Olney, Mrs. F. F. Prentiss, Ruth C. Roush, and the Friends of Art.

We offer our deep thanks to Betsy Pinover Schiff and Jerry M. Lindzon, both of whom made generous contributions toward publication costs. The Friends of Art Fund and the Stephanie Wiles Museum Publication Fund were also instrumental in providing for photography and production costs. The Friends of Art—founded in 1938 by Hazel B. King, the museum's first curator—provides critical support for a wide range of projects, helping to ensure meaningful encounters between the public and the museum collection. The Wiles Fund was set up by members of the museum's Visiting Committee, chaired by Carl R. Gerber, and others to honor Stephanie Wiles, the director of the Allen Memorial Art Museum from 2004 to 2011. As this is the first publication made possible in part through the Wiles Fund, we would like to recognize here its many contributors: Ellen Adams, Maryan and Chuck Ainsworth, Paul B. Arnold, Robert and Helen Baldwin, Eric Bautista, Douglas Baxter, Roger Berry, Louis and Janet Bertoni, Elaine Bridges, Frederick Carlson and

Dorothy Terry, William Cornell, Joan Danforth, Sarah Epstein and Donald Collins, Carol Ganzel, Carl R. Gerber, Catherine Gletherow, Peter and Barbara Goodman, George Haley, Suzanne Hellmuth and Jock Reynolds, Maxine Houck, William Katzin and Katie Solender, Thomas Kren and Bruce Robertson, Marvin Krislov and Amy Sheon, Barbara Martin, Albert and Connie Matlin, Charles and Nancy Matthews, Emily and T. K. McClintock, Albert McQueen, Nicola and John Memmott, Florence Muller, Annabel Perlik, Mysoon Rizk and John Richardson, Howard Rubin, Odile Schempp, Wendy and Richard Schwartz, Deborah and Andy Scott, Ruth Searles, J. Merrill and Patricia Shanks, Jean and Ralph Shaw, Alan Steinberg and Patricia Mooney, Fay Stern, Athena Tacha and Richard Spear, Robert Taylor and Ted Nowick, Don and Mary Louise VanDyke, Gloria Werner, Richard Wiles, Stephanie Wiles and Jeff Rubin, Barbara Wolanin and Phil Brown, James Zemaitis, and Michael and Driek Zirinsky.

Our colleagues on the museum staff have shown a tireless commitment to this project, for which we are grateful. Megan Harding, the museum's manager of publications, provided a keen editorial eye and worked closely with Marquand Books to make this publication possible. Registrar Lucille Stiger has served as a conscientious custodian of the collection, collaborating with staff at ICA-Art Conservation to prepare Latin American artworks for publication and exhibition. Assistant Registrar Selina Bartlett undertook the many responsibilities relating to rights and reproductions, while working closely with photographers Dirk Bakker and John Seyfried to ensure that the collection would be beautifully represented. Preparators Kendall Christian and Michael Reynolds skillfully assisted with the photography of often challenging objects, while museum security officers also helped ensure that the sessions ran smoothly. Student curatorial assistants Sarah Konowitz (OC 2013), Nicole Alonso (OC 2013), and Mallory Cohen (OC 2015) provided thorough research that contributed valuable information about the artworks, and we thank Professor Steven S. Volk for his insightful essay and inspiring dedication to teaching with art at the Allen Memorial Art Museum. Sally Moffitt, the museum's administrative assistant, helped with the myriad tasks related to catalogue distribution, and curators Liliana Milkova, Jason Trimmer, and Andaleeb Banta have used many of the works in academic and public outreach while providing collegial cheer.

Finally, we wish to warmly thank the Board of Trustees of Oberlin College, President Marvin Krislov, and Acting Dean of the College of Arts and Sciences Joyce Babyak; their steadfast support of the Allen Memorial Art Museum and its many programs ensures that the museum continues to fulfill its role in furthering Oberlin's educational mission.

Andria Derstine
John G. W. Cowles Director

Denise Birkhofer
Assistant Curator of Modern and Contemporary Art

Foreword

The Allen Memorial Art Museum (AMAM) at Oberlin College, with an encyclopedic collection of over 14,000 works, is justly celebrated for its important holdings of Asian, European and American, and modern and contemporary art. Until now, however, its twentieth- and twenty-first-century Latin American works have not, as a distinct group, been widely known by scholars or the general public. This volume —the first publication to focus on this aspect of the museum's collection—does not aim to present the artworks contained here in exhaustive detail; rather, Denise Birkhofer, the museum's assistant curator of modern and contemporary art, has provided new information and significant insight into about 60 of its finest examples through 35 entries on individual artists. Additionally, a comprehensive checklist of the AMAM's holdings of modern and contemporary works from this region will serve to make better known the breadth and depth of the museum's collection of Latin American and Latino art.

Artworks from Latin America have been part of Oberlin College's collections since well before the AMAM opened to the public in 1917. In the nineteenth and early-twentieth centuries the college received many gifts of art from alumni and other donors. Among these gifts were thousands of works bequeathed in 1904 by Charles Fayette Olney (1831–1903). Olney, the founder of the New York Teachers Association and vice president of the Cleveland School of Art, was particularly interested in the educational value of art—one of the guiding principles of what was to become the AMAM. He had publicly displayed his collection in his home in the Tremont neighborhood of Cleveland since 1893—effectively opening his private museum to all—and his bequest to Oberlin College aimed to ensure that his works would be used for educational purposes. Importantly, his gift came without restrictions, and only some works were kept; others were sold in the ensuing years, with the monies used to purchase objects of superior quality. Among the hundreds of works in the Olney bequest that remain in the AMAM today are eight Mexican objects, in silver, hard stone, and carved coconut shell, dating from antiquity to the nineteenth century.

Joining the Mexican works from Olney's bequest, an Argentinian silver spoon entered the collection in 1917, part of a large gift of spoons from Mary Thompson Springer on the occasion of the museum's opening. These nine modest objects

are the only Latin American artworks presently in the collection that were acquired prior to the first modern work by a Latin American artist, the 1933 print *Negroes* by José Clemente Orozco. As Birkhofer discusses in her introductory essay, the AMAM's acquisition of that print in 1936 marked the start of many decades of sustained interest in collecting twentieth- and twenty-first century works by Latin American and Latino artists, with more than 200 such works in the collection today.

Acquisitions of Pre-Columbian and nineteenth-century works from Central and South America continued, too, well beyond the earliest donations. Textiles, and works in terracotta, fiber, and hard stone entered the collection through both gift and purchase in the decades from the 1940s to the 1990s. Among these are a nineteenth-century Mexican terracotta vase that was a gift of Mrs. Malcolm L. McBride, whose important additions to the AMAM's Latin American collection are detailed in Birkhofer's essay; a group of Mexican samplers acquired in 1942 from the estate of Amos B. McNairy (1854–1942), an Oberlin College trustee and Cleveland industrialist; numerous Peruvian ceramics and textiles that were museum purchases; a group of four Costa Rican ceramics that were gifts of Martha Morton Langston (OC 1944); and five Pre-Columbian and Peruvian earthenware vessels that were gifts in honor of Hannah M. Richman (OC 1995) from her parents Hershel and Dr. Elizabeth Richman. The AMAM additionally houses a group of unaccessioned terracotta and stone Pre-Columbian works that were donated by its first director, Professor Clarence Ward, to form a study collection. Eminent alumnus André Emmerich (OC 1944), the important New York dealer and authority in Pre-Columbian art (also well-known for his work with Color Field painting and other twentieth-century art movements), sold four works in the 1960s and 1970s to the museum, including a Mexican terracotta funerary mask, a Mayan terracotta tripod plate, a Peruvian pottery jar, and a Mexican terracotta figure.

Thus the works described in this catalogue do not exist in a vacuum; in addition to their many connections with the AMAM's other renowned twentieth- and twenty-first century works, a number of them display resonances with the earlier artistic traditions of Central and South America, as Birkhofer has ably shown. That all these works, ranging from Pre-Columbian to the present, are actively used in teaching across the curriculum in Oberlin's College of Arts and Sciences is a testament to their excellence and to the active engagement of the museum staff and college faculty—as Professor Steven Volk discusses in his essay—with the limitless educational possibilities of original works of art.

Andria Derstine
John G. W. Cowles Director

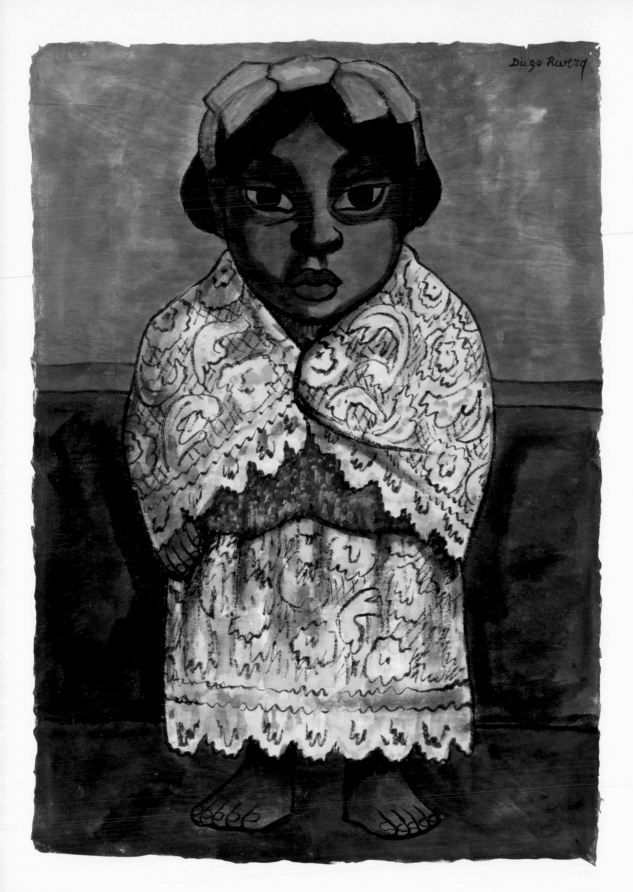

Latin American Art at the Allen
Building a Collection

Denise Birkhofer

When I recently asked a group of nearly thirty undergraduate students to name as many Latin American artists as they could, the Mexicans Frida Kahlo and Diego Rivera came quickly to mind, yet no further names were offered. My question was posed to Oberlin College students in an introductory course in Latin American Studies, many of whom were majors in that field or came from Latino backgrounds. This scenario reflects the current state of general awareness of Latin American art, in which much remains unknown beyond such assumed notions as the supposedly inherent "magical realism" most often associated with figures like Kahlo and Rivera.[1] This book aims to communicate the diversity and richness of art in Latin America through an examination of the similarly varied works of modern and contemporary art in the collection of the Allen Memorial Art Museum.

As is often discussed by scholars, the term "Latin America" is notoriously problematic, implying a hegemonic, European-derived culture that fails to accurately represent the region.[2] The present publication considers art from the twentieth and twenty-first centuries by artists from Central and South America, as well as the Caribbean, whose national language is derived from Latin. While this parameter clearly encompasses the many Hispanic countries of the region, it also includes Portuguese-speaking Brazil and Francophone Haiti. The "Latin" modifier here does not discount the importance of non-European cultures in the region, such as the impact of the African diaspora on Brazil, Haiti, and other Caribbean islands such as Cuba. Similarly palpable is the presence of indigenous populations throughout the Americas, to which many of the artists in the AMAM collection respond in their works.

In 1936, the Allen Memorial Art Museum purchased its first work by a contemporary artist from Latin America: José Clemente Orozco's lithograph *Negroes*, part of the print portfolio *The American Scene No. 1* (fig. 2). Acquired by the AMAM in its entirety, the portfolio features scenes of pressing social and political issues in the United States by such artists as Reginald Marsh, Thomas Hart Benton, and John Steuart Curry. In Orozco's gut-wrenching image, the hanged and burning black bodies are based on a 1930 photograph of the lynching of George Hughes, a Texas laborer who was falsely accused of rape and murder. Since this first acquisition, the AMAM collection of Latin American art has grown to encompass more than

FIG. 1 Diego Rivera (Mexican, 1886–1957), *Portrait of a Girl*, ca. 1945. Watercolor. Charles F. Olney Fund, 1947.30. © 2014 Banco de México Diego Rivera Frida Kahlo Museums Trust, Mexico, D.F. / Artists Rights Society (ARS), New York

200 objects. While many of the earliest acquisitions were prints, the collection now also has excellent examples of drawing, painting, sculpture, photography, and installation. Most strongly represented are artists from Mexico, Cuba, Chile, and Brazil, while others come from Argentina, Colombia, Guatemala, Haiti, Peru, Puerto Rico, and Uruguay. Also included are several Latino artists born in the United States but with roots in Latin America.

Following the Orozco purchase, the AMAM's next forays into collecting contemporary Latin American art occurred in the 1940s with the acquisition of several works of Mexican Modernism. This trend was in keeping with the practices of other United States institutions, perhaps best exemplified by New York's Museum of Modern Art, which, through the impetus of Director Alfred H. Barr, became widely recognized as the first institution outside of Latin America to consistently collect art from the region.[3] In the 1930s, a fascination for art from "south of the border" became widespread among American audiences, who were attracted to the idyllic subject matter of Mexican works made for export.

Two early female patrons of the Mexican School had a great impact on the AMAM's Latin American collection: Lucia McCurdy McBride and Leona E. Prasse. Mrs. McBride (1880–1970) was a noted suffragist, promoter of women's rights, and art collector from Cleveland, Ohio (fig. 3). She and her husband, Malcolm L. McBride, were supporters of the Cleveland Institute of Art, the Cleveland Play-house, and the Cleveland Museum of Art, and donated to the last a large portion of their art collection, primarily constituted of European and American art of the nineteenth and early twentieth centuries. Mrs. McBride also collected art by

figures associated with the Mexican School, such as Jean Charlot, Rufino Tamayo, and *los tres grandes* (Diego Rivera, José Clemente Orozco, and David Alfaro Siqueiros). Rivera's lithograph *Self-Portrait* and Orozco's painting *Mexican House* (see pages 88 and 20), both gifts of Mrs. McBride, were the first two examples of Latin American art donated to the AMAM. These were followed by three others from the McBride collection by Mexican artists Miguel Covarrubias, Carlos Orozco Romero, and Jesus "Chucho" Reyes Ferreira. These five Mexican works—a fraction of the 128 diverse art objects given to the AMAM by Mrs. McBride between 1935 and 1969—formed the basis of the museum's Latin American collection.

Perhaps due to the influence of Mrs. McBride, in 1945 the AMAM purchased a color lithograph by the French-born Charlot, *Mother and Child*, which depicts a typical Mexican School subject: an indigenous woman grinding corn, a sleeping baby slung to her back. Mrs. McBride played a direct role in facilitating the museum's purchase of two Mexican works in 1947, acquired directly from commercial venues in Mexico City. Diego Rivera's *Portrait of a Girl* (fig. 1), which depicts a barefoot girl with dark skin and a colorful regional costume, is an example of the artistic response to the market demand for folkloric works. Procured at the same time was Guillermo Meza's painting *Nopalera* (see page 69), which likewise adopts as its subject the Mexican female, here united with the iconic cactus of the country's landscape. The Rivera and Meza were the first examples of unique, non-serial contemporary Latin American artworks purchased by the museum.

The budding collection was expanded through the gifts of Leona E. Prasse (1896–1984), a longtime curator in the Cleveland Museum of Art's prints and drawings department and wife of Charles G. Prasse, owner of Prasse Lumber Company in Cleveland. Recognized for her scholarship on the graphic works of German-American artist Lyonel Feininger, Mrs. Prasse collected American and European prints and drawings dating from the Renaissance to the twentieth century. While hundreds of works from the Prasse collection were given to the Cleveland

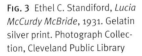

Fig. 3 Ethel C. Standiford, *Lucia McCurdy McBride*, 1931. Gelatin silver print. Photograph Collection, Cleveland Public Library

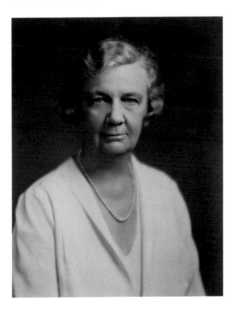

Museum of Art and New York's Metropolitan Museum of Art, the AMAM received twenty-eight prints between 1948 and 1978. Included were twelve lithographs relating to the legacy of the Mexican Revolution by Rivera, Orozco, and Siqueiros. These gifts, along with those of Mrs. McBride and early purchases made by the AMAM, established the museum as an active collector of Mexican Modernism.

The first examples of Latin American abstraction came to the AMAM in 1956 via two contemporary drawings by Cuban artists René Portocarrero and Raul Milian (fig. 4). Donated by Joseph Cantor—an Indianapolis-based business owner and collector of Cuban modernism, including some of the most celebrated paintings by Wifredo Lam—these abstract works introduced a new note to the AMAM collection and offered a dramatic formal contrast to the social realism of the Mexican School. A suite of four lithographs by Guatemalan artist Carlos Mérida, a gift of Art Institute of Chicago curator of modern art and gallerist Katharine Kuh (1904–1994)—who also gave eighteen other significant modernist works by such artists as Man Ray, Alexander Calder, and Mark Rothko—increased the number of abstract works in the AMAM collection. The most important example of painted abstraction in the museum's Latin American collection came in the form of Fernando de Szyszlo's enigmatic painting *The Execution of Túpac Amaru* (see page 103), a 2007 gift of Norman and Jean Moore, the latter an Oberlin College graduate of 1938.

The Latin American collection has grown exponentially since the 1990s, due in part to a number of large gifts of contemporary art. Between 1995 and 2013, Oberlin alumni Cristina Delgado and Stephen F. Olsen (OC 1980 and 1979) donated fifty-two works that greatly diversified the collection, thirty-nine of them by Latin American artists. A contemporary art advisor with Cuban roots, Delgado has collected work by Caribbean artists, such as Puerto Rican painter Arnaldo Roche-Rabell

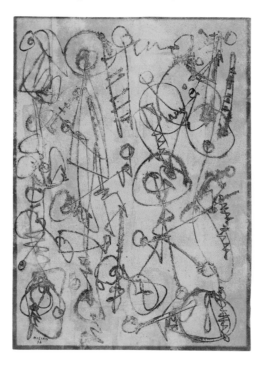

FIG. 4 Raul Milian (Cuban, 1914–1986), *Composition*, 1952. Ink and wash. Gift of Joseph Cantor through the Smithsonian Institution, 1956.8

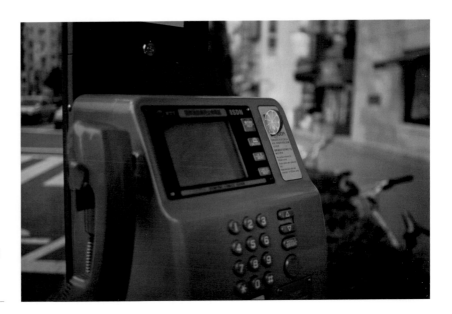

and Cubans Carlos Alfonzo, Luis Cruz Azaceta, José Bedia, Consuelo Castañeda, Tomás Esson, Carlos Garaicoa, and Felix Gonzalez-Torres. Having worked closely with the estate of Ana Mendieta, Delgado donated to the AMAM three works by the Cuban émigré, as well as the collage *KalyAni* (see page 19) by her sister Raquelín Mendieta, all four of which explore iconography of the sacred and the feminine. Gifts from the Delgado and Olsen collection also include numerous works by artists from South America, such as a sculpture by Colombian artist Doris Salcedo and an installation by Uruguayan artist Rimer Cardillo, both of which address themes of political violence. Works by Brazilian artists include a three-dimensional collage by Ernesto Neto, four drawings by Mauro Piva, and Cildo Meireles's *Zero Dollar*, a conceptual work that wittily subverts the economic power of the United States through the artist's creation of his own counterfeit currency. Representing Chile are three expressionist paintings and a print by Ismael Frigerio, four photographic works by Alfredo Jaar, and Juan Downey's 1986 video *J. S. Bach* from the series *The Thinking Eye*, the first example of Latin American video art to enter the AMAM collection. Also from the Delgado and Olsen collection are six color photographs by Gabriel Orozco, which represent some of the Mexican artist's most compelling works. In *Lemon Distance Call* (fig. 5), the artist playfully inserts a slice of lime in the coin slot of a pay phone.

The recent gifts of Jerry M. Lindzon, a Miami-based attorney and prominent collector of contemporary art, further revolutionized the AMAM collection. Among the seventeen gifts from the Lindzon collection are two mixed-media works by Brazilian artist Jac Leirner, a drawing by Mexican artist Nahum B. Zenil, and a multimedia installation by the artist collective known as assume vivid astro focus. A particularly notable addition is Edouard Duval-Carrié's painting *Justicia* (see page 45), the first work by a Haitian artist to enter the AMAM collection. Another important work is Alfredo Jaar's *The Body is the Map* (see page 53), which, together with the four examples from the Delgado and Olsen collection, as well as another

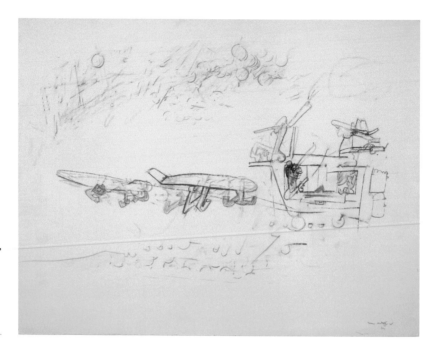

Fig. 6 Matta (Chilean, 1911–2002), *Wild West*, 1962. Pencil and colored crayons. Gift of Allan and Jean Frumkin, 2013.67.3. © 2014 Artists Rights Society (ARS), New York / ADAGP, Paris

purchased by the museum in 1991, strongly represent the oeuvre of the politically engaged artist.

The AMAM has built up a similarly impressive body of work by Jaar's Chilean compatriot Matta (born Roberto Antonio Sebastián Matta Echaurren). These include a drawing and three prints from Chicago-based collectors Kenneth and Barbara Watson, as well as five additional drawings and a color lithograph from the family of art dealer Allan Frumkin. While many of the Matta works represent the surrealist and geometric style most associated with the peripatetic artist, the five Frumkin drawings illustrate a whimsical, representational subject: the Wild West, complete with cowboys, horses, stagecoaches, and shoot-outs (fig. 6).

In recent years, graphic work by contemporary Mexican artists has also become an area of strength and a fitting complement to the AMAM's notable collection of Mexican prints from the early twentieth century. Many of these works—including those by Enrique Chagoya, Artemio Rodriguez, and Francisco Toledo—were gifts of Oberlin alumni Michael and Driek Zirinsky (OC 1964 and 1965), former professors of history and English at Boise State University. The Zirinskys, who began to collect art as graduate students while living in Paris, now prefer to support artists living and working in the United States. In addition to works by California transplants Chagoya and Rodriguez, the Zirinskys likewise donated to the AMAM *Platinum Blue Bicycle* (fig. 7), an Oldenburg-esque soft sculpture by Texas-based Margarita Cabrera that addresses themes of immigration and mobility.

The representation of photography in the Latin American collection has also vastly expanded in recent years. In 1989, the AMAM purchased its first example, the Cibachrome print *Ejaculate in Trajectory* (see page 99) by Andres Serrano. This acquisition was followed by two others by the Latino artist in 1991 and 2009, and was soon joined by photographic works by Alfredo Jaar, Gabriel Orozco, and Ana

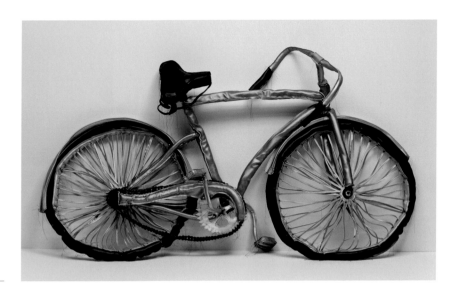

Mendieta. Recent additions include a suite of four early digital photographs by Cuban artist Consuelo Castañeda and a Cibachrome print by Brazilian Miguel Rio Branco, gifts of Delgado and Olsen. The AMAM acquired from Oberlin alumnus Kenneth Schwartz (OC 1967) and Nancy Schwartz its first work by Manuel Álvarez Bravo, an artist known as the "Father of Mexican Photography," while New York collectors Anne and Joel Ehrenkranz, donors to the AMAM of more than forty significant works of contemporary art, gave the AMAM its first example by Brazilian photographer Vik Muniz. In 2013, the museum added an important group of eighty-four vintage gelatin silver prints by German émigré Hugo Brehme, which capture the people, landscape, and architecture of Mexico in idyllic, Pictorialist views (fig. 8).

This volume, intended as an introduction to the AMAM's modern and contemporary Latin American art collection, as well as a resource for scholars and the public, is published on the occasion of the museum's first comprehensive exhibition of these works, *Latin American and Latino Art at the Allen*. This exhibition continues a long legacy of interest at Oberlin in contemporary art from the region, exemplified by such endeavors as Athena Tacha Spear's seminal 1970 exhibition *Art in the Mind*, which included conceptual art by Rafael Ferrer (Puerto Rico), Eduardo Costa (Argentina), and Luis Camnitzer (Uruguay). In 1974, the AMAM presented *Towards a Profile of Latin American Art*, organized by the Center for Art and Communication in Buenos Aires, which featured 148 works of conceptual and new-media art by contemporary artists from Argentina, Brazil, Chile, Colombia, Paraguay, Peru, Uruguay, and elsewhere. In 1987, the AMAM hosted *Corresponding Worlds: Artists' Stamps*, which was guest curated by American mail artist Harley and featured 200 works by more than fifty international artists. Many of the participants hailed from Latin America, reflecting the popularity of mail art for facilitating artistic exchange across the region. Included in the show were works by well-known Argentinian mail artists Graciela Gutiérrez Marx and Edgardo Antonio Vigo, two of the many Latin American artists represented in the extensive collection of mail art

maintained by the Clarence Ward Art Library at Oberlin College. The AMAM's collection of early-twentieth-century Mexican art was featured in the 2008 teaching exhibition *The Mexican Revolution in Prints and Paintings* organized by Professor of History Steven S. Volk and Colette Crossman, former curator of academic programs, in conjunction with Oberlin students in the course "The Mexican Revolution: Birth, Life, Death," which is discussed in the following essay.

Individual works from the Latin American collection have been continuously incorporated into exhibitions throughout the years, and will continue to be featured as outstanding examples of the AMAM's permanent collection. It is the aim of the present catalogue to promote awareness and use of this significant resource among Oberlin's many constituents and the broader public. It is also hoped that our readers will come away with a perspective on Latin American art that extends far beyond Rivera, Kahlo, and the "magically real" to encompass abstraction, activism, and everything in between.

NOTES

1. Edward J. Sullivan, "Introduction," in *Latin American Art in the Twentieth Century* (London: Phaidon, 2000), 9.

2. Ibid., 8–9.

3. Miriam Basilio, "Reflecting on a History of Collecting and Exhibiting Work by Artists from Latin America," in *Latin American & Caribbean Art: MoMA at El Museo* (New York: The Museum of Modern Art, 2004), 52–54.

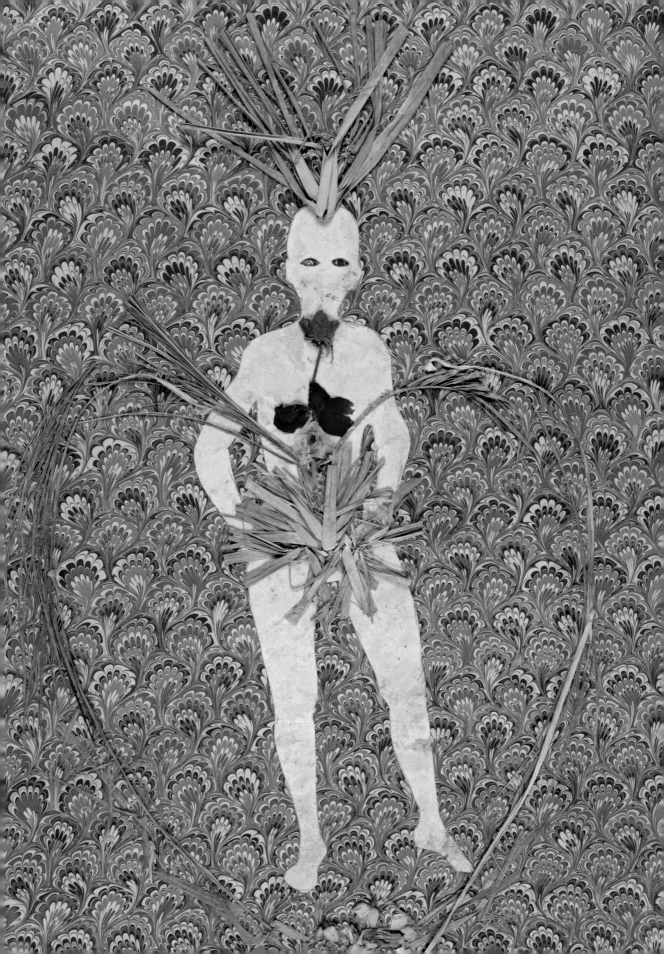

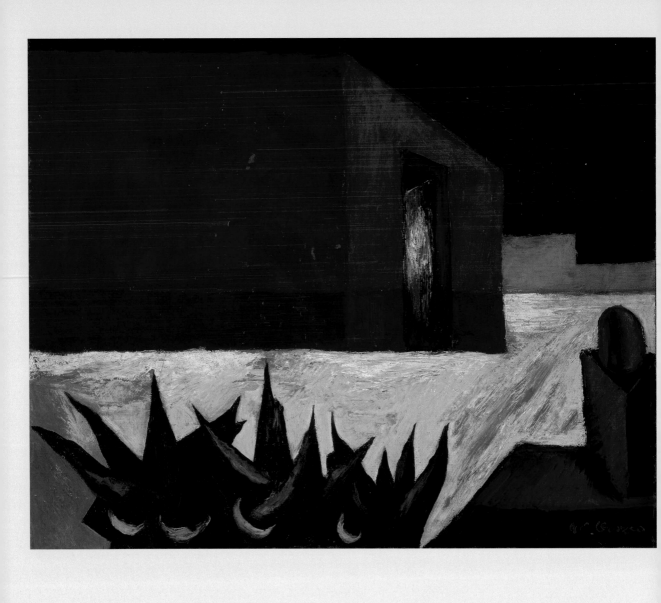

Art and Evidence

Teaching the Mexican Revolution at the Allen Memorial Art Museum

Steven S. Volk

A ghostly figure stands in the doorway of a building, more bunker than house. No windows shed light on the interior. Nor is the space outside the squat structure more welcoming: a sharply pointed *agave* plant hugging the bottom of the frame threatens to prick your eye if you stare too closely; barren sand fills the yard and the chimney tucked in the lower right corner looks to have drifted off from the house, like an island separating from an ancient Pangaea. *Mexican House* was painted in 1929 by José Clemente Orozco, one of the *tres grandes* (three giants) whose murals have come to define the Mexican Revolution. Unlike the work of Diego Rivera, another of the *grandes*, Orozco's bleak vision underscored an exhausted process that had failed to deliver on its promises.

Orozco's small easel work confronted me with an unexpected challenge. Colleagues in the Allen Memorial Art Museum (AMAM) invited me to give a museum talk focusing on the *Mexican House* (fig. 9). I agreed, but with considerable trepidation. A Latin American historian, while I also study museums, I am not an *art* historian. What could I say about this, or *any*, painting? I was visited by the anxiety dreams that usually trouble a teacher's sleep the week before classes start, the ones where you are standing alone on a stage, wearing only a bathrobe, about to perform Joaquín Rodrigo's *Concierto de Aranjuez*, when it dawns on you that you have not picked up your guitar in a quarter century and the orchestra is nowhere in sight.

The talk, all drama aside, went well. I focused on conflicts that shattered the revolutionary forces in Mexico and how Orozco's radicalized vision had been shunted to the side, creating his decidedly pessimistic outlook. Whether my gracious audience learned anything is hard to say; but I did, and some seeds of understanding planted that afternoon began to sprout into a more substantial awareness of how all faculty members, not just those trained in art-historical methods, could use the museum and its encyclopedic resources to deepen student learning. Lecturing in front of Orozco's *Mexican House*, I understood that I had abandoned my familiar location as expert and become, for a moment, a novice.

As experts, we not only know more than our students, but we know differently; knowing more changes *the way we know*. Experts organize knowledge at a deeper level than novices, focusing not on what can be observed, but on underlying

FIG. 9 José Clemente Orozco (Mexican 1883–1949), *Mexican House*, 1929. Oil on canvas. Gift of Mrs. Malcolm L. McBride, 1943.273. © 2014 Artists Rights Society (ARS), New York / SOMAAP, Mexico City

concepts or laws.[1] In terms of teaching, this means that we encounter barriers to problem solving or conceptual analysis at substantially different points than our novice students. Speaking about Orozco made me more acutely aware of how the demands that experts place on novice learners can lead to anxieties that complicate learning. But I also realized how art could be used to engage the students' learning potential in truly productive ways. I began to explore the AMAM's vibrant Latin American collection as a dynamic resource for students of Latin American history, imagining how to use art as evidence to bolster my students' historical understanding.

TEACHING WITH ART—"THE MEXICAN REVOLUTION: BIRTH, LIFE, DEATH"

I soon decided to redesign my Mexican Revolution seminar—a course I had offered many times previously—using the AMAM collection as an essential teaching resource. Among the museum's prints are defining works from the three Mexican masters: Rivera, Orozco, and David Alfaro Siqueiros. As I examined each work with an eye toward teaching, I began to see how the art could help my students negotiate the remarkably complex revolutionary process, one whose intricacies had stymied them in the past.

Working closely with Colette Crossman, the AMAM's then curator of academic programs, I co-curated an exhibition, *The Mexican Revolution in Prints and Paintings*, which opened in fall 2008 and coincided with my seminar, "The Mexican Revolution: Birth, Life, Death." At that point, each exhibition label provided just the basic facts, such as the name of the artist, title and date of the work, and accession number; I provided the introductory wall text. When classes began, students enrolled in the seminar visited the gallery with an eye toward selecting one print

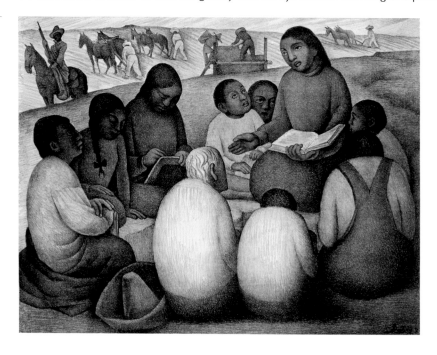

FIG. 10 Diego Rivera (Mexican 1886–1957), *Open-Air School*, 1932. Lithograph. Gift of Leona E. Prasse from the Mr. and Mrs. Charles G. Prasse Collection, in honor of Ellen H. Johnson, 1977.95. © 2014 Banco de México Diego Rivera Frida Kahlo Museums Trust, Mexico, D.F. / Artists Rights Society (ARS), New York

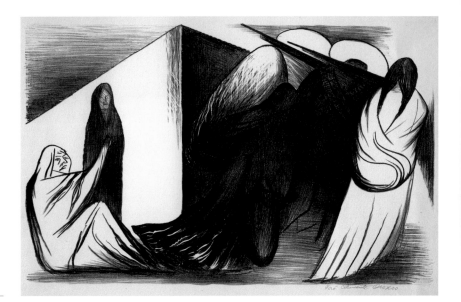

or painting to work with over the course of the semester. In class, they kept their chosen work in mind as we examined the historiography and cultural texts of the revolution, from 1910 to the present.

My students took on the responsibility of writing extended labels for their selected works. When mounted in the exhibition, these short texts would introduce the visitor not just to the art, but also to the Mexican Revolution. The history we examined in class gave students the confidence and ability to write from a position of expertise. Their labels situated the works in historical context, highlighting the contrasting visions of the artists by reference to the multiple currents defining the Mexican Revolution. Each work offered a single strand that, when viewed with the others, allowed the visitor a clearer understanding of the complex revolutionary fabric.

In *Open-Air School* (fig. 10), Diego Rivera sympathetically portrays a rural, indigenous teacher at her lessons in the unsettled Mexican countryside. An armed horseman guards the teacher, her students, and the workers in a nearby field, signaling a continuing need for vigilance. "Education," wrote Robin Holmes (OC 2009), who had selected this lithograph, "was a central part of Diego Rivera's perspective on how to empower and unify the lower classes, a perspective shared by the revolutionary governments in the 1920s and 30s . . . The image . . . shows Rivera's preference for scenes of the post-revolutionary reconstruction of Mexican life, as opposed to muralists like Orozco who often portrayed the violence, disillusionment, and suffering of the war years. Although not their primary medium, lithographs nevertheless proved a useful supplementary source of income for muralists and a means of disseminating their images to a wider audience."[2]

"The Mexican Revolution shook the lives of an entire nation, not just those who fought or represented the state," wrote Sara Skvirsky (OC 2009), who studied Orozco's harrowing lithograph, *Marching Women* (fig. 11). Her label narrative reminded viewers that, "José Clemente Orozco uses fighting men as a backdrop

to highlight the narrative of women in a period of extreme strife. As with much of his work, Orozco reveals an uncertain future for both those joining the battle and those who remain behind."

In addition to the label-writing assignment, each student composed a three- to five-minute audio podcast on his or her selected work. The project allowed students to create an expanded narrative, developing their historical arguments while keeping in mind the broad audience that would hear the recordings. On a technical level, this aspect of the project allowed students to experiment with sound design as a means of improving oral presentations.

TEACHING WITH ART: WHAT IS GAINED?

Three aspects of the seminar contributed in a significant manner to student learning. In the first place, as abundant research shows, students learn more when actively creating knowledge, not passively receiving it.[3] My students understood that they were preparing text for a "real" audience, one not confined to their classroom. Their labels would be on public display and the text would be incorporated into the museum's permanent database. The podcasts, too, would be maintained as resource material. Secondly, my students realized that the drastic synthesis needed to create an exhibition label could happen only when they truly understood their subject. Most found it harder to create a 125-word label than a 20-page paper. Finally, in the process of working with a single piece of art, students were compelled to slow down and concentrate. To the extent that the digitally dynamic world students inhabit acts to fragment attention, projects that require concentration and reflection can reinforce deep engagement.[4]

To succeed in the world, our students must engage at a consistently high level with written texts, both as producers of written work and as careful readers. But it is no less true that, as we live in a world of images, our students must be able to read, understand, and question visual materials.[5] Working with images in the

classroom—and even more so in the emotive context offered by original works in the museum—is a powerful means of acquiring these skills. By learning to read images, students can sharpen their ability to make meanings according to what James Paul Gee calls the "multimodal principle," emphasizing that "meaning and knowledge are built up through various modalities … not just words," and that students will be expected to negotiate textual and visual sources in the world outside the classroom.[6] Image and words interact contrapuntally, as text and counter-text, allowing students to question the meaning of evidence by placing one beside the other.

For history students in particular, working with art in the museum context encourages close reading and concentrated attention. The experience heightens their ability to evaluate visual evidence, weigh conflicting interpretations, and recognize change over time. Working with the prints and paintings of the Mexican Revolution at the Allen Memorial Art Museum helped my students to realize on an immediate level how dominant, official narratives can take root in our imaginations and shape the fundamental ways we think about the past, even as they crowd out alternative visions. In the end, they not only appreciated, but also could articulate, why we needed the tumultuous sweep of competing visions to better comprehend the Mexican Revolution.

NOTES

1. National Research Council, "How Experts Differ from Novices," in J. D. Bransford, A. L. Brown, and R. R. Cocking, eds., *How People Learn: Brain, Mind, Experience, and School*, expanded ed. (Washington, DC: National Academies Press, 2000), 31–50.

2. Full text labels can be found in the AMAM's online database of works at *http://allenartcollection.oberlin.edu/emuseum/*.

3. See, among others, Daniel L. Schwartz and John D. Bransford, "A Time for Telling," *Cognition and Instruction* 16:4 (1998): 475–522.

4. Jennifer L. Roberts, "The Power of Patience: Teaching Students the Value of Deceleration and Immersive Attention," *Harvard Magazine* (Nov.–Dec. 2013), 40–43.

5. Elizabeth Thomas, Nancy Place, and Cinnamon Hillyard, "Students and Teachers Learning to See: Part I: Using Visual Images in the College Classroom to Promote Students' Capacities and Skills," *College Teaching* 56:1 (Winter 2008): 23–27.

6. James Paul Gee, *What Video Games Have to Teach Us about Learning and Literacy* (New York: Palgrave Macmillan, 2003), 210.

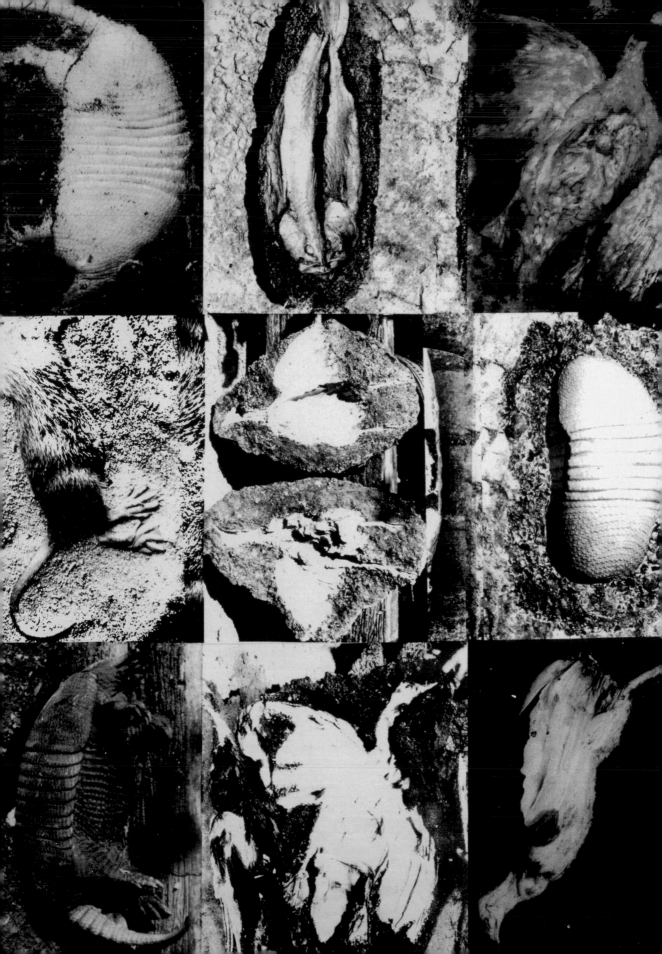

Selected Works

Manuel Álvarez Bravo Mexican, 1902–2002

El Ensueño
(The Daydream)

1931, printed later
Gelatin silver print
10 × 8 in.
Gift of Kenneth (OC 1967) and
Nancy Schwartz, from the col-
lection of Gary Schwartz
(OC 1962), 2013.39
© Colette Urbajtel / Archivo
Manuel Álvarez Bravo, SC

Widely recognized as the most important figure in the history of Mexican photog-
raphy, Manuel Álvarez Bravo experimented with numerous photographic tech-
niques and stylistic approaches throughout his lengthy career. His output ranges
from documentary photographs that record the human condition to formal studies
bordering on abstraction. Trained in his youth by German émigré Hugo Brehme,
who is represented by eighty-four photographs in the AMAM collection (see
pages 36–39), Álvarez Bravo first tried his hand at Pictorialist views of the Mexi-
can landscape. He soon adopted his signature "straight photography" aesthetic,
marked by careful framing and avoidance of subsequent manipulation in the dark-
room. Many of his Mexican street scenes capture the "decisive moment," a term
coined in reference to the photographs of Álvarez Bravo's French contemporary
Henri Cartier-Bresson.

Álvarez Bravo's career advanced in 1931 when he won a major photographic
competition for the Tolteca cement company and landed his first solo exhibition
at the Galería Posada. *The Daydream* was created that year; it captures a young
girl on a balcony in the midst of reverie, one of Álvarez Bravo's numerous striking
images of the people and sights of everyday life in Mexico. The work's reference
to the world of dreams prefigures his later involvement with the European Sur-
realists, many of whom immigrated to Mexico during World War II. Álvarez Bravo
was dubbed "a natural surrealist" by the group's leader André Breton. He contrib-
uted work to several Surrealist exhibitions and publications from 1938 to 1940,
such as *Good Reputation Sleeping*, which depicts a reclining nude female partially
wrapped in bandages and surrounded by spiny cacti.

assume vivid astro focus (avaf)

This multimedia installation work comprises seven pieces that can be mixed and matched. The AMAM collection includes *Garden 3*, a wallpaper design of brightly colored biomorphic forms that may be scaled to fit any desired space; *Ashtray*, a decal that can likewise be reproduced in any size and installed on any surface; and four decals printed on Plexiglas to create three-dimensional images (*Sinister Smile and Pasta*, *Carla and Skull*, *Graffiti LA 1*, and *Graffiti LA 4*). The final component of the installation is the animated film *Pills & Cigarettes*, which features swirling psychedelic patterns, dancing figures, and flashing representations of household items.

Assume vivid astro focus (avaf) is spearheaded by Eli Sudbrack (b. 1968), a Brazilian-born artist based in New York since 1998, who often collaborates with French artist Christophe Hamaide-Pierson (b. 1973). Together they create large-scale, ephemeral installations that are layered to promote overstimulation of the senses. Campy photographic images culled from various pop culture sources are spliced together with neon colors and animation. While avaf's scope is

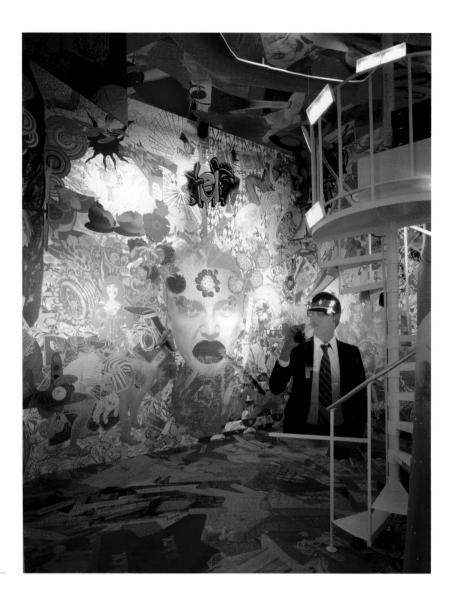

Fig. 1 *assume vivid astro focus VIII* at the Whitney Biennial, Whitney Museum of American Art, New York, March 11–May 30, 2004. Mixed-media installation © assume vivid astro focus

international, the collective's work often references aspects of the culture of Sudbrack's native Brazil, such as Carnival celebrations.

Avaf's installations and performances encourage active viewer participation. In *a very anxious feeling*, which was installed in 2007 at John Connelly Presents in New York, visitors were asked to don "half trannie masks" equipped with 3D glasses to view the environment, which was covered in 3D wallpaper. The AMAM's Plexiglas sculptures *Sinister Smile and Pasta* and *Graffiti LA 4* were featured in avaf's multimedia environment, *assume vivid astro focus VIII* (fig. 1), at the 2004 Whitney Biennial.

Luis Cruz Azaceta Cuban, b. 1942

The Journey

1988
Acrylic on paper
39⅝ × 52 in.
Gift of Cristina Delgado
(OC 1980) and Stephen F.
Olsen (OC 1979), 2000.23
© Luis Cruz Azaceta

Raised in Havana, Luis Cruz Azaceta fled Fidel Castro's Cuba for the United States in 1960 at the age of 17. Eventually settling in New York, Azaceta began creating art that focused on such social concerns as violence, displacement, and exile, often utilizing his personal narrative as a vehicle to address universal themes. In *The Journey*, a looming head in profile, recognizable by the distinctive nose as Azaceta's self-portrait, is fused with the form of a boat on choppy waters. The subject refers not only to the artist's own escape from his homeland, but also to the hardships experienced by all immigrants and exiles, as suggested by the figure's head, bowed in melancholy and resignation. Azaceta's painting also references the often-fatal attempts of refugees from Cuba and other Caribbean islands to reach American soil on makeshift rafts or unstable boats. The potential dangers of immigration are mirrored by Azaceta's aggressive painting style, marked by the use of vibrant colors and gestural brushstrokes and drips, which reflect the artist's interest in the work of German Expressionist artist Max Beckmann, as well as in graffiti art.

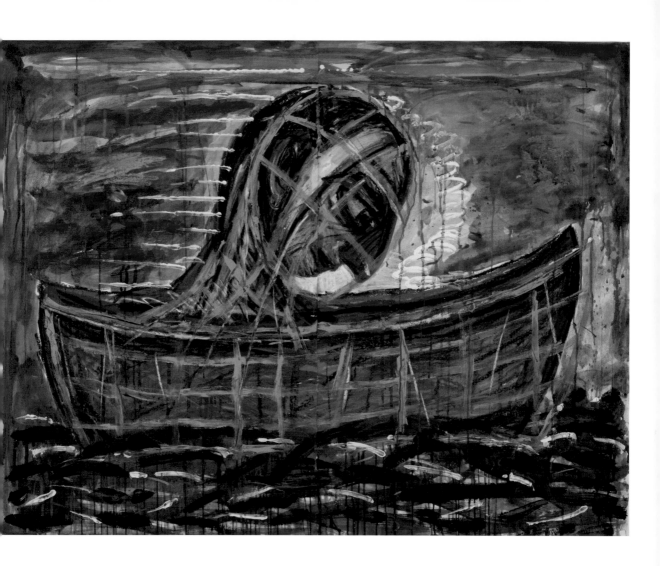

José Bedia Cuban, b. 1959

Con Licencia
(with detail)

1991
Ink on amate paper
47 × 95 in.
Gift of Cristina Delgado
(OC 1980) and Stephen F.
Olsen (OC 1979), 2011.14.4
© José Bedia. Courtesy
of George Adams Gallery,
New York, NY

Afro-Caribbean spiritual traditions permeate the work of Miami-based artist José Bedia. In 1984, the Cuban native was initiated as a priest of Palo Monte Mayombé, a religion introduced to the region by slaves from the Congo. Taking its name from *palo*, the Spanish word for "stick," the religion centers on belief in the spiritual power of the Earth and natural objects. To facilitate their rites, Paleros create consecrated vessels known as *Nganga* that are filled with such materials as dirt, sticks, and bones, and thought to be inhabited by spirits of the dead.

Bedia illustrates a Palo ritual in the monumental ink drawing *Con Licencia*, whose title translates to "with permission." At the center of the composition, a kneeling supplicant presents a machete to the waning moon and requests permission from the creator-god Nsambiampungo—highest deity in the Palo pantheon—to cut down a plant emerging from the ground as an appendage of the personified Earth. Connecting moon, supplicant, and plant is a diagonal axis formed of the words of the Palero's chant, scripted in a mixture of Spanish language and Kikongo dialect. The symbol rendered directly above the severed plant is known as a *firma*, or chalk drawing composed of graphic elements such as arrows, crosses, and circles to facilitate a specific ritual.

Bedia's use of amate paper reflects his interest in numerous traditions beyond those of the African diaspora, such as Mesoamerican cultural practices and the indigenous shamanism of Peru.

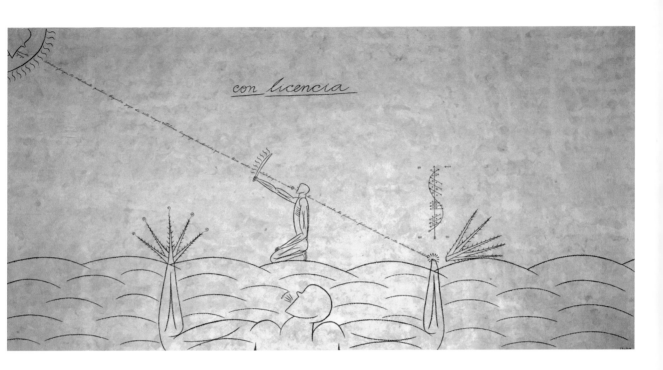

con licencia

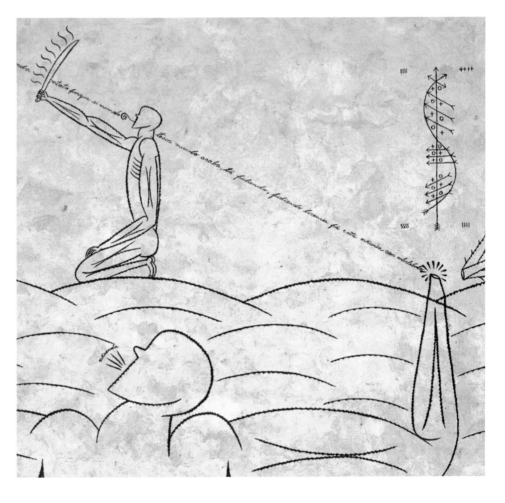

Hugo Brehme German, active in Mexico, 1882–1954

Born in Eisenach, Germany to a middle-class family, Hugo Brehme settled in Mexico in 1905 after traveling through Africa and Central America. He opened a photography studio in Mexico City, where he garnered much success from the images taken during his travels around Mexico. Presenting both urban and rural views of the country, these images were often produced as postcards and widely disseminated abroad. Brehme continued to work in Mexico for the last fifty years of his life, receiving Mexican citizenship two years before his death in 1954. Widely recognized as the founder of Pictorialist photography in Mexico, Brehme applied the aesthetics of painting to the medium of photography through such techniques as framing and selective focus. He produced one of the most important groups of images documenting the Mexican Revolution (1910–17) and also served as an early mentor to the "Don of Mexican Photography," Manuel Álvarez Bravo.

The AMAM has a collection of eighty-four photographs by Brehme, each mounted on paperboard in the manner of a study portfolio, with identifying information such as the pictured location inscribed in pencil underneath. Many were reproduced in Brehme's 1923 book *Picturesque Mexico*, published in both Mexico and Germany. They include scenes taken in the countryside, with cacti in the foreground and volcanoes or mountains looming in the distance. Brehme often posed figures within his compositions to complete his idyllic vision of Mexico, such as the *campesino* leading a donkey in the foreground of *Popocatépetl, Cholula*. Yet much of Brehme's subject matter was urban, capturing panoramic city views, street scenes, and architecture; a number of the AMAM photographs document the exteriors and lavish interiors of churches across Mexico.

Brehme also dedicated himself to documenting Mexico's cultural heritage, both ancient and modern, turning his lens on pre-Hispanic artifacts from Mexico City's National Anthropology Museum in such images as *Mayan Goddess, Museo Nacional*, whose dramatic formalism contrasts with his Pictorialist landscapes. Other photographs capture Mexico's numerous Pre-Columbian archeological sites, such as Teotihuacan and Chichén Itzá. Brehme also documented the artistic contributions of his contemporaries, such as Diego Rivera's mural cycle for the Cortés Palace in Cuernavaca.

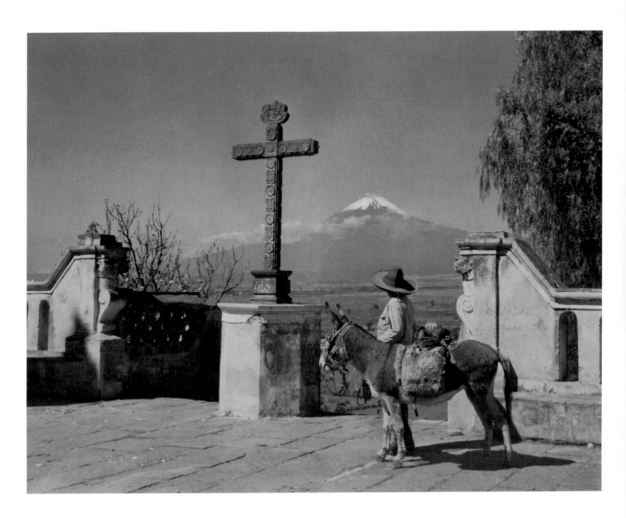

Brehme sought out people as his subjects as readily as he did locations. In addition to images of revolutionaries, he also photographed Mexican vendors and others in the midst of everyday activities. Known in Spanish as *tipos*, these images of "social types" were often mass-produced so they could be collected as a set. These *tipos* relate to the practices of photographer Eugène Atget, who captured similar images of people on the streets of Paris. Brehme also documented the traditional costumes worn by the people indigenous to various regions of Mexico. In the highly staged and romanticized composition of *Tepotzotlán*, a man and woman outfitted in the popular dress of the *charro* and the *china poblana* appear in an archway opening to a view of a church.

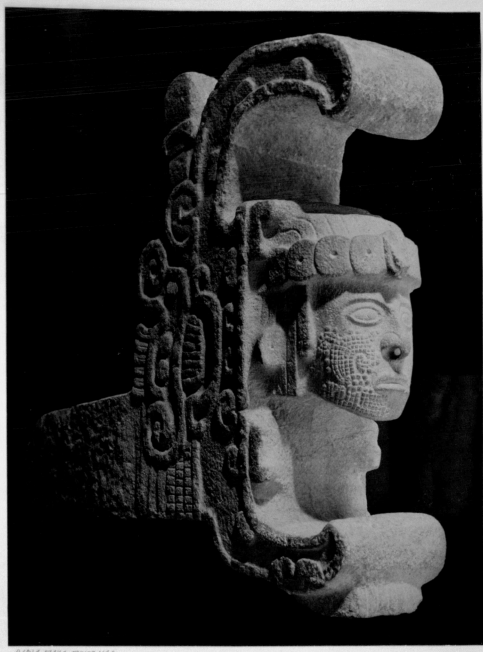

DIOSA MAYA MUSEO NAC.

Mayan Goddess,
Museo Nacional

1905–25
Sepia-toned gelatin silver print
$13\frac{3}{16} \times 10\frac{9}{16}$ in.
Allen Memorial Art Museum,
2013.7.3

Tepotzotlán

1905–25
Sepia-toned gelatin silver print
$14\frac{3}{4} \times 9$ in.
Allen Memorial Art Museum,
2013.7.44

Rimer Cardillo Uruguayan, b. 1944

Silent Barrack

1989
Wood, paper, pastel, graphite,
metal, dirt, and gravel
Framed relief print: 106 ×
54 × 7 in.
Sink: 24 × 24 × 16¼ in.
Driftwood: 34½ × 5½ in.
Gift of Cristina Delgado
(OC 1980) and Stephen F.
Olsen (OC 1979), 1995.14.1A–E
© Rimer Cardillo

The large-scale installations of Rimer Cardillo address issues of history, memory, loss, and spiritualism. He assembles his works from a wide range of symbolically meaningful materials, many of which he personally collects. In *Silent Barrack*, for example, the battered sink was recovered from an abandoned industrial building that housed his New York studio, while the ring of soil refers to Cardillo's displaced homeland, which he left in 1979 to escape the oppressive dictatorship of Aparicio Méndez. The amorphous form within *Silent Barrack*'s looming wooden frame represents Cardillo's complex relationship with his native Uruguay: its corpse-like shape recalls for the artist childhood memories of seeing a slaughtered lamb, as well as the political torture and disappearance of a close friend. A metal pole leans precariously against the relief, contributing to the work's sense of transience. Cardillo's placement of these elements creates a shrine-like aesthetic, indicative of an unknown ceremonial function.

A second AMAM work by Cardillo likewise addresses themes of mutability and death. The *Vanishing Tapestries* series reproduces documentary photographs of biological specimens taken during excavation of La Quebrada de los Cuervos gorge in eastern Uruguay. Stark black-and-white images of armadillos, birds, plants, skulls, and other remains are presented in a grid format that suggests scientific classification. Cardillo selected the protected natural site as his subject because of its history as a military training ground in the 1980s, during which time the gorge suffered significant ecological damage. The AMAM work is just one element that originally was part of a larger installation of several tapestries. Meant to overwhelm the viewer with its monumentality, *Vanishing Tapestries* was exhibited at the Bronx Museum of the Arts in 1998, and on the exterior of the Uruguay pavilion at the Venice Biennale in 2001. Although fabricated from silkscreened canvas (rather than from woven thread), the series refers to the medium of tapestry and its strong associations with European notions of royalty and power, as such displays of wealth traditionally decorated the walls of palaces.

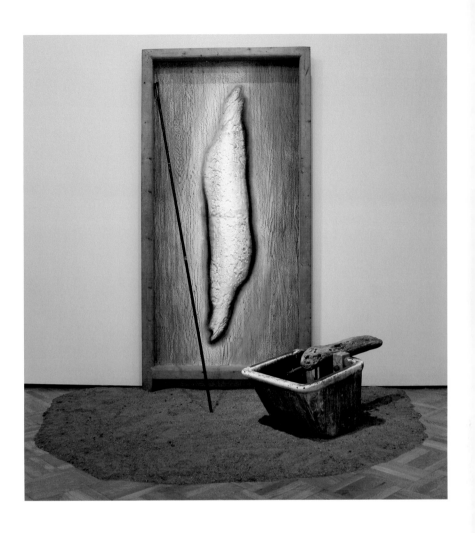

Untitled, from the series
Vanishing Tapestries

1996
Photo-silkscreen on canvas
76 × 64½ in.
Gift of Cristina Delgado
(OC 1980) and Stephen F.
Olsen (OC 1979), 1997.37.4
© Rimer Cardillo

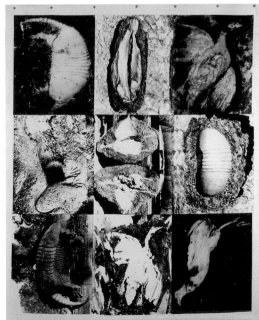

Enrique Chagoya Mexican, b. 1953

*Codex Espangliensis:
From Columbus to the
Border Patrol*
Enrique Chagoya with author
Guillermo Gómez-Peña (Mexi-
can, b. 1955) and printer Felicia
Rice (American, b. 1954)
2000
Ink and color on amate paper
Portfolio: $9\frac{3}{16}$ × $11\frac{3}{4}$ × $1\frac{3}{4}$ in.
Gift of Michael (OC 1964) and
Driek Zirinsky (OC 1965) in
honor of Frederick B. Artz,
2013.38
© Enrique Chagoya

*Das Tausendjährige
Reich*
1995
Acrylic and oil on amate paper
$47\frac{7}{8}$ × 73 in.
Gift of Michael (OC 1964)
and Driek (OC 1965) Zirinsky,
2013.48.4
© Enrique Chagoya

Born in Mexico City, Enrique Chagoya moved to the United States in 1977, where he later became an art professor at Stanford University. Chagoya's works navigate loaded cultural elements from north and south of the border, combining iconography from Pre-Columbian traditions, Catholicism, and popular culture. Similar to earlier graphic artists such as Honoré Daumier, Francisco de Goya, and José Guadalupe Posada, Chagoya employs humor and satire to address complex social and political issues.

Codex Espangliensis: From Columbus to the Border Patrol is executed on amate, a form of paper made in Mexico since pre-Hispanic times that was popularly used by the Aztecs for recordkeeping and communication. Much like the ancient codices burned in vast quantities following the Spanish Conquest, this accordion-folded, limited-edition artist book features primarily pictorial information.

Violence and the rewriting of history are the overarching subjects of the *Codex Espangliensis*, which interlaces expressive typography, images of famous figures —Che Guevara, Minnie Mouse, George Washington, Aztec deities, Wonder Woman, Christ, and others—and iconic objects such as army tanks and bottles of Coca-Cola. The hand-painted illustrations in *Codex* include scenes of Mexican peasants praying to the American dollar, conquistadors greeted by native peoples, and a display of ritual cannibalism.

Das Tausendjährige Reich (German for the "Thousand-Year Empire," another term for the Third Reich) addresses similar themes of colonialism, war, and destruction. Also executed on amate paper, the composition features diverse elements adrift in blood-red waters: sea monsters, bloated corpses, a sunken house, television set, crucifix, missile, and the gloved hands of Mickey Mouse. A series of skulls is visible under the painting's surface, contributing to the grisly atmosphere.

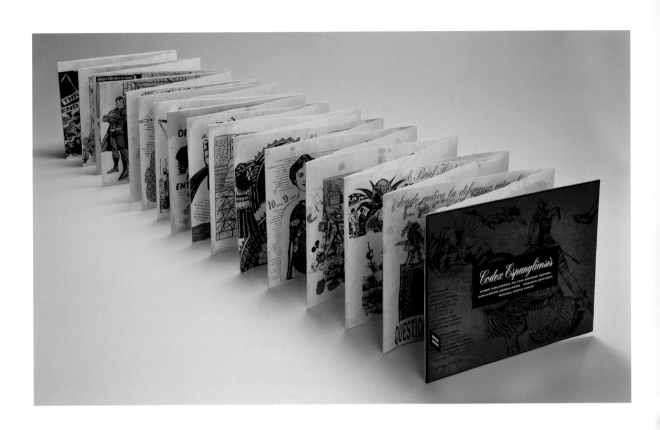

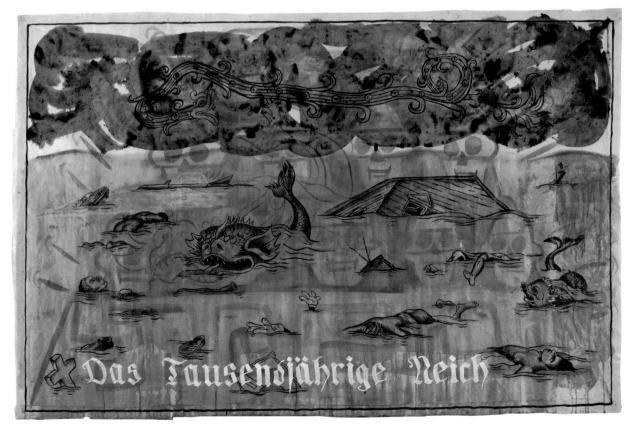

Edouard Duval-Carrié Haitian, b. 1954

Justicia

1998
Oil on canvas with aluminum frame
54½ × 46½ × 2¼ in.
Gift of Jerry M. Lindzon,
2012.6.6
© Edouard Duval Carrié

The first work by a Haitian-born artist to enter the AMAM collection, Edouard Duval-Carrié's *Justicia* presents an elaborately costumed female in a landscape, surrounded by a sculptural metal frame. Reflecting Duval-Carrié's interest in the rich history and culture of his native country, permeated by the presence of colonialism and Vodou religious traditions, *Justicia* stems from a body of work created in Paris that addresses the Haitian Revolution (1791–1803). The AMAM's painting depicts one of the last major battles of that revolution, when former slave and future emperor Jean-Jacques Dessalines emerged victorious over the French army. Dominating the composition is the allegorical figure of Justice, who intervenes on behalf of the rebels. The army's encampment is nestled in the dark, lush landscape, while a uniformed officer sits at her feet in the left foreground. Depicted with colorful wings and Creole facial features, Justice is armed with her attribute of the flaming sword; smaller swords similarly decorate the bodice and full skirt of her European-style dress. Draped above the scene is a banner of blue and red, the colors of the Haitian flag, as well as a plaque that identifies the allegorical subject.

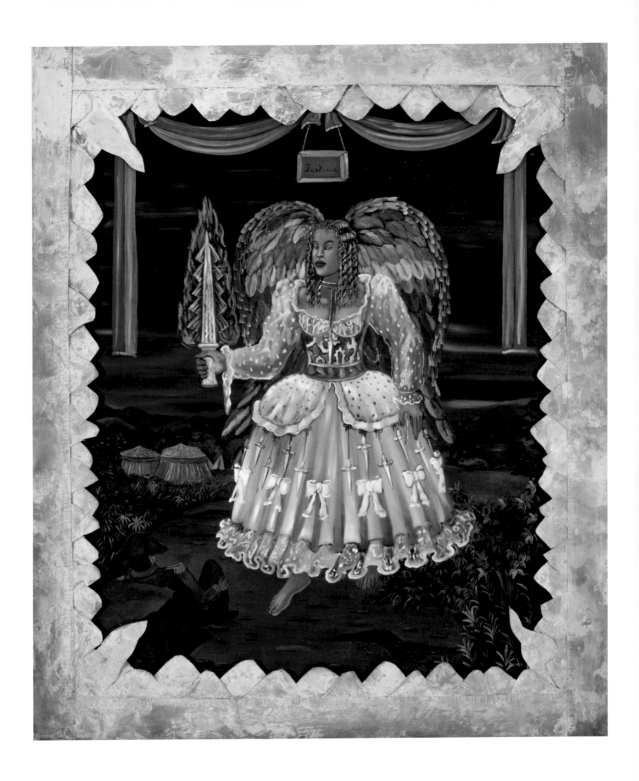

Ismael Frigerio Chilean, b. 1955

The Laughing Flames III

1990
Tempera and acrylic on canvas
70 × 52 in.
Gift of Cristina Delgado
(OC 1980) and Stephen F.
Olsen (OC 1979), 1995.14
© 2014 Artists Rights Society
(ARS), New York / CREAIMAGEN,
Santiago

Born in Santiago, Chile, Ismael Frigerio studied philosophy before turning to art. His monumental canvases, thickly painted with expressionistic lines in a variety of media, feature highly abstracted compositions peopled by mythic figures. Frigerio explores universal themes or events of historical significance, such as the Spanish conquest of the Americas. In addition to addressing the violence of colonialism, Frigerio also produced a series of works alluding to the atrocities committed by the regime of dictator Augusto Pinochet, which were part of the daily experience of Chileans and prompted the artist to relocate to New York in 1979.

Four paintings comprising a series titled *The Laughing Flames*, the third of which is in the AMAM collection, refer to the regular practice by Pinochet's secret police of dumping the bodies of their opponents in the Mapocho River. The canvases depict obscured figures floating in a dark, ambiguous setting, their Christ-like bodies wrapped in white shrouds. The series title may refer to Frigerio's interest in the four elements—fire, water, air, and earth—or to the immolation scene in Richard Wagner's opera *Götterdämmerung*, in which the Valkyrie Brünnhilde throws herself upon "the laughing flames" of her lover Siegfried's funeral pyre.

One of three other works by Frigerio in the AMAM collection, the silkscreened print *Sacred Blood* also suggests the transformative power of immolation. Head raised and open-mouthed as if in ecstasy, a self-portrait of the artist appears engulfed by a field of blood-red flames. Like the shrouded figure in *Laughing Flames III*, the reference to the blood of Christ here also injects a religious undertone. Two additional drawings, *Study for Lust of Conquest* and *Landscape with Fish*, likewise address themes of colonialism and violence with painterly expressionism.

Carlos Garaicoa Cuban, b. 1967

Windmills; Because Every City Has the Right To Be Called Utopia
Installation detail
Pins and thread
Overall (approx.): 6 × 12 ft.
© Carlos Garaicoa

Template for *Windmills; Because Every City Has the Right To Be Called Utopia*
2001
Gift of Cristina Delgado (OC 1980) and Stephen F. Olsen (OC 1979), Dolores Delgado, Elena Delgado, and William Hilton, 2010.9
© Carlos Garaicoa

Responding to the state of modern cities—his native Havana, in particular—Carlos Garaicoa confronts the utopian ideals ascribed to modernist architectural spaces, which in reality have fallen into ruin and decay. The artist examines these themes in conceptual works that span photography, sculpture, and installation.

Windmills; Because Every City Has the Right to be Called Utopia is one in a series of thread drawings that Garaicoa first exhibited in 2001 at Lombard-Freid Fine Arts in New York. To create the thread drawings, dozens of pins are inserted into the wall at the composition's intersection points, using the artist's template as a guide. Thread is then wound around the pins to create the lines of the drawing, which in the case of *Windmills* represents a field of wind turbines receding into the distance. The larger windmills in the foreground are made of cobalt blue thread, while those in the background are a lighter blue. Despite its monumental size of approximately six feet high and twelve feet wide, the resulting three-dimensional drawing appears fragile and evanescent. Thread lines shift and disappear based on one's viewpoint, while the even less-tangible shadows of the composition are projected onto the wall behind.

The field of wind turbines suggests a utopian vision for sustainable energy that could power future urban spaces. These modern machines may also refer to the famous windmills in the seventeenth-century Spanish novel, *Don Quixote*, which the protagonist perceived as giant, threatening foes. Given this context, the choice of windmills as a subject may function as a veiled criticism of Cuba's repressive political system, which Garaicoa dare not criticize openly. The artist's skepticism of the utopian ideals of modernist architecture likewise extends to the grandiose aspirations of a socialist society.

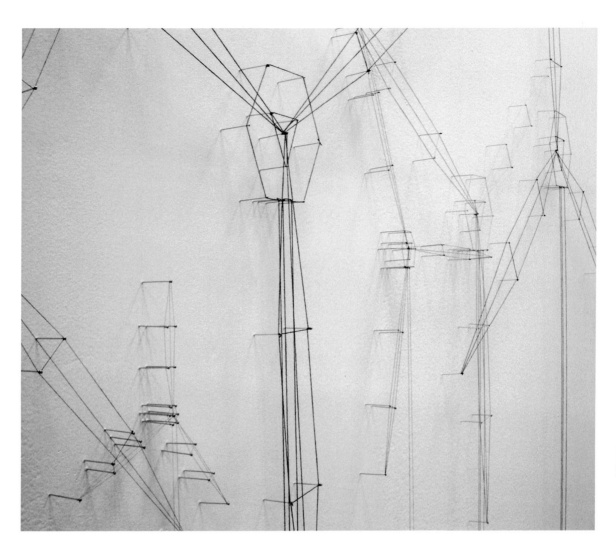

AZUL OSCURO

CYAN

Quisqueya Henríquez Cuban, b. 1966

Two Skins

1995
Mixed-media installation
Overall: 24 × 23 × 18 in.
Metal plate: 24 × 28 in.
Gift of Jerry M. Lindzon,
2012.6.5 A–B
© Quisqueya Henríquez

Born and educated in Havana, Quisqueya Henríquez currently lives and works in Santo Domingo in the Dominican Republic. She works in a variety of media, including prints, collage, installation, video, and sound, and addresses such issues as race, ethnicity and gender. Henríquez's approach demonstrates concern for the situation of Latin America in a global context, as well as the relationship of that region's visual production to the art historical canon.

In the mixed-media sculpture *Two Skins*, a leather tent-like object is suspended from wires and hovers over a metal plate on the ground. Visible on the floor of the open tent is a photograph that depicts an extreme close-up of the surface of the artist's own skin, peppered with freckles, moles, and hair. The juxtaposition of leather and human skin—the "two skins" of the work's title—also serves to conflate the corporeal with the architectural, as elements associated with the body are given a new structural form. For Henríquez, the association of the body with shelter relates to her experiences of geographic displacement as an immigrant. The organic leather contrasts with the industrial metal sheet, while both take the form of basic geometric shapes. In its placement directly on the floor, *Two Skins* shares much with Minimalist and Post-Minimalist sculpture, requiring the visitor to walk around the work to fully perceive it.

Two Skins was shown in 1995 at a benefit auction show at the New Museum of Contemporary Art in New York. Henríquez made the work in Miami, where she lived from 1993 to 1997, a time when she worked closely with fellow Cuban artist and former teacher Consuelo Castañeda (b. 1958). The AMAM collection also includes four early digital photographs from Castañeda's 1998 series *Speed-Split*, which likewise focus on the artist's body as their subject.

Alfredo Jaar Chilean, b. 1956

The Body is the Map

1990
Nine Cibachrome prints
Frame (each): 20 × 20 × 1⅞ in.
Overall: 70 × 70 in.
Gift of Jerry M. Lindzon,
2012.6.1.1A–I
© Alfredo Jaar

Architect, photographer, filmmaker, and installation artist Alfredo Jaar left his native Chile in 1981 at the height of Augusto Pinochet's dictatorship. He settled in New York, where he dedicated himself to tackling such provocative political and social issues as genocide, military violence, and the imbalance of power between industrial and developing nations. As part of his activist mission, Jaar often adopts alternative forms of dissemination—billboards and signs, for example—to confront the public with tragedies occurring around the globe that are more comfortably ignored. In *Rushes* (1986–87), Jaar installed images of Brazilian gold miners from the Serra Pelada mine in a New York City subway station, where the oppressive conditions of the exploited Amazonian workers were juxtaposed with data reflecting the market price of gold.

Similar to contemporary photographers like Jeff Wall, Jaar has worked extensively with the light box as a support for his photographs—an attractive option due to its associations with advertising as well as its dramatic luminosity. The AMAM collection includes two light-box works related to Jaar's series on Brazilian miners. In *Terra Non Descoperta*, the image of a worker struggling with a heavy load is overlaid with an excerpt from the diary of Christopher Columbus's first voyage to America. The text discusses the generosity of the indigenous people, who reportedly gave gold to the new arrivals as freely as they would pour water from their gourds, highlighting the disparity of wealth and power between colonizers and colonized.

The AMAM's second light-box work also features an image of an Amazonian gold miner and comes from a portfolio produced by Photographers and Friends Against AIDS, *In a Dream You Saw a Way to Survive and You Were Full of Joy*. The edition of twenty-five, intended to raise funds for AIDS-related research and health care, features photographs by Andres Serrano, Lorna Simpson, Joel-Peter Witkin, Jeff Wall, and others in a portfolio box designed by Jenny Holzer. Jaar's involvement with this project illustrates the breadth of his social concerns, which may reach halfway around the world or land closer to home.

The Body is the Map derives from Jaar's series *Coyote!*, which focuses on individuals who assist undocumented Mexicans in crossing the border to the United States. The central image shows the back of an elderly coyote's head; the veins

The silk-screened text on the box reads:

Katale Refugee Camp, north of Goma, Zaire
50 kilometers north of Goma, Zaire
Wednesday, August 31, 1994

This photograph shows a section at what is the largest refugee camp in the world. Interspersed within the hills and valleys north of Goma, the camps Katale, Kibumba, and Mugunga house 50% of the estimated two million Rwandese refugees who fled their homes and villages. This massive exodus occurred in just twelve weeks.

In addition to cholera, pneumonia, malaria and dysentery, the refugees must also contend with looting, attacks, stoning and the monotony of daily life in the camps. A solitary tree stands amidst hundreds of thousands of makeshift blue and white tents scattered throughout the landscape as far as the eye can see.

Camp, from the project
Real Pictures

1994–95
Cibachrome print in a black
linen archive box with silk-
screened text
2 × 11 × 8¾ in.
Gift of Cristina Delgado
(OC 1980) and Stephen F.
Olsen (OC 1979), 2004.13.4 A–B
© Alfredo Jaar

and lines on his aged neck are repeated in various orientations throughout the surrounding grid of prints. The likening of the body to a map suggests not only the trajectory of a person's life—a record of which is apparent on one's very skin—but also the often politicized, geographic mobility of bodies.

After traveling to Rwanda in August 1994, Jaar embarked on an extensive humanitarian endeavor known as the *Rwanda Project* (1994–2000). A direct witness to the aftermath of ethnic genocide that killed nearly one million people and displaced countless others, Jaar documented the situation through photographs and survivor interviews that contributed to a number of installations. One such project, *Real Pictures,* commissioned by New York's Museum of Contemporary Art in 1995, featured more than 550 black archival boxes, each concealing a photograph within. Similar to Minimalist sculpture, the boxes were arranged in rows or stacked in groups directly on the floor in a modular fashion. Jaar intended this "cemetery of images," in his words, to present the enormity of the tragedy without bombarding the viewer with images to the point where "we don't see them anymore." Jaar instead denies the viewer access to the images, whose subject matter is described in the artist's own words in white text on the cover of each box.

Three boxes from the *Real Pictures* project are represented in the AMAM collection. Two of these contain images from the Katale refugee camp in Zaire, while the third depicts the entrance to the Ntarama Church in Nyamata, where 400 Tutsi

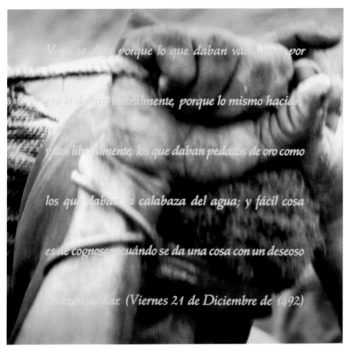

*Terra Non Descoperta
(Undiscovered Land)*
(detail)

1991
Light box and color
transparency
20½ × 20½ × 5¼ in.
Gift of Cristina Delgado
(OC 1980) and Stephen F.
Olsen (OC 1979), 2004.13.2
© Alfredo Jaar

Untitled, from the
portfolio *In a Dream
You Saw a Way to
Survive and You Were
Full of Joy*

1990
Laminated Duratrans transpar-
ency, fluorescent light box
24 × 20 × 5½ in.
Horace W. Goldsmith Foun-
dation Photography Fund,
1991.35.4
© Alfredo Jaar

men, women, and children were massacred during Sunday Mass. To conjure an image of the hidden photographs, the viewer must rely on Jaar's texts, which provide both factual and descriptive information. For example, one AMAM work from Katale is inscribed with the following:

> This photograph shows a section of what is the largest refugee camp in the world. Interspersed within the hills and valleys north of Goma, the camps Katale, Kibumba, and Mugunga house 50% of the estimated two million Rwandese refugees who fled their home and villages. This massive exodus occurred in just twelve months. In addition to cholera, pneumonia, malaria and dysentery, the refugees must also contend with looting, attacks, stoning and the monotony of daily life in the camps. A solitary tree stands amidst hundreds of thousands of makeshift blue and white tents scattered throughout the landscape as far as the eye can see.

Jac Leirner Brazilian, b. 1961

Brazilian artist Jac Leirner creates her works from disposable products of con-
sumer culture that she personally collects, such as plastic bags, empty cigarette
packs, or business cards. These banal items are transformed into sculpture when
installed *en masse* in a gallery setting, arranged on the wall or directly on the floor
in configurations that recall the works of Minimalist or Post-Minimalist artists such
as Donald Judd and Eva Hesse. This working method is apparent in two works by
Leirner in the AMAM collection, *Prize* and *Little Blue Phase.*

Prize, comprised of forty-four ashtrays and boarding passes, is part of the *Cor-
pus delicti* series (1993–2001) that Leirner made of materials taken from airplanes.
The series title—Latin for "body of crime" and a legal term for the material evi-
dence of a crime—refers to Leirner's subversive act of pilfering objects from air-
craft. The ashtrays are associated with particular boarding passes that identify the
seat locations to which they once belonged. In the AMAM work, the ashtrays and
tickets, which display airline logos such as Lufthansa, Iberia, American Airlines,
and Swiss Air, are carefully arranged under a Plexiglas cover.

Leirner's second series in this vein, *Fase Azul (Blue Phase,* 1991–98), stems
from her long engagement with paper currency as a found material. The AMAM
work from that series, *Little Blue Phase,* comprises thousands of one-hundred
cruzado notes, the lowest denomination circulating at a time when Brazil's econ-
omy was suffering runaway inflation, rendering these bills relatively worthless. By
transforming this weak currency into art, Leirner plays with the notion of value. Her
painstaking efforts in effecting the transformation are an important element of the
final product. Each banknote had to be collected, sorted, punched with a hole, and
threaded onto a supporting cord; this laborious process serves to restore value
to the notes. The series title *Blue Phase* stems from the color of this issue of the
cruzado note, which features an image of Juscelino Kubitschek, president of Brazil
from 1956 to 1961.

The first iteration of Leirner's money pieces, *Os cem (The One Hundreds)* had
involved hundreds of pink *cruzeiro* bills. She intended *Blue Phase* as a reference to
Pablo Picasso's so-called Blue Period, traditionally ascribed to his somber works
of 1901–04, which he followed with the more optimistic Rose Period.

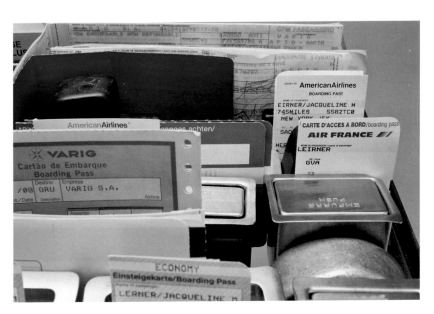

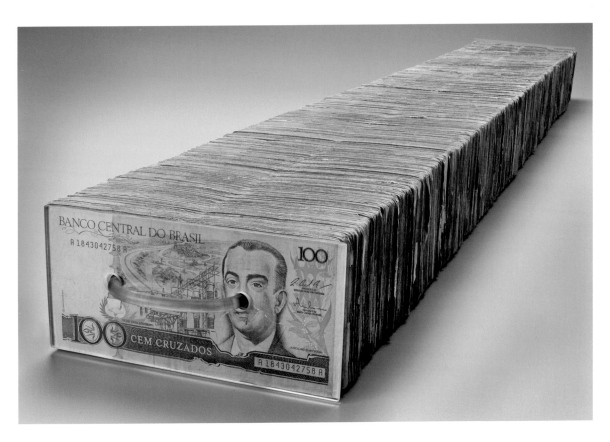

Francisco Mata Rosas Mexican, b. 1958

Mictlán, from the series
México Tenochtitlán

1997
Gelatin silver print
15⅞ × 19¾ in.
Ruth C. Roush Contemporary
Art Fund, 2013.10
© Francisco Mata Rosas

Photographer Francisco Mata Rosas has dedicated his career to documenting modern life in his native Mexico City and beyond. With a background in photojournalism, Mata Rosas focuses on subjects ranging from crowded subway cars to the political conflict in Chiapas.

In his series *México Tenochtitlán*, Mata Rosas explores Mexican culture, both ancient and modern. The images feature religious rituals, popular festivals, weekend leisure activities, panoramas of the Mexico City center, and other views of urban street life. He often juxtaposes symbols of present-day Mexico with those representing pre-Hispanic precedents, hence the titular reference to Tenochtitlán, capital of the Aztec Empire upon which Mexico City is founded.

Mictlán depicts the bustling subway station at the Zócalo, the geographic and symbolic heart of the capital, peopled by commuters and street vendors. A skeleton-costumed figure at the center of the composition seems to emerge like a personification of Death from the bowels of the underworld, a reference that is further supported by the work's title, *Mictlán*, the name for the Aztec realm of the dead. This image was likely captured during the festivities of Day of the Dead, in which the memory of loved ones is celebrated through such activities as the construction of offering altars and the wearing of *calavera* (skeleton) masks.

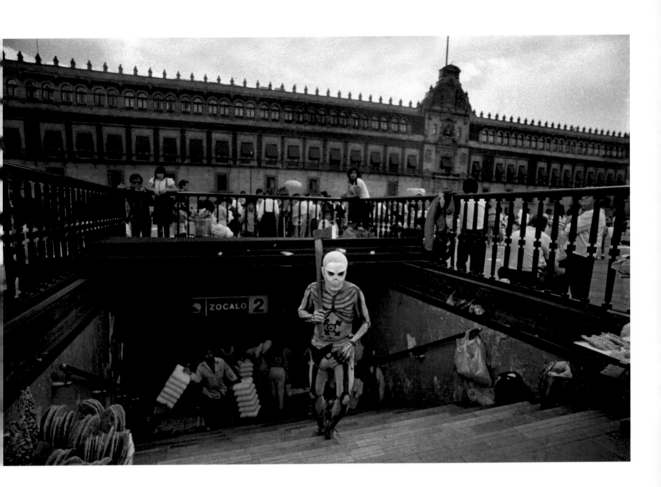

Matta Chilean, 1911–2002

The Chilean-born artist known as Matta (Roberto Antonio Sebastián Matta Echaurren) lived a peripatetic lifestyle, alternately setting up shop in such locations as New York, Paris, London, and Rome, and living out his final years in Tarquinia, Italy. Trained as an architect at the Catholic University of Santiago, he moved to Paris in 1933 to work in the studio of Le Corbusier. During his travels through Europe from 1936 to 1939, he made contact with many highly influential figures of the day, including Spaniards Salvador Dalí and Federico García Lorca, Bauhaus notables Walter Gropius and László Moholy-Nagy, and French Surrealists Marcel Duchamp and André Breton. Impressed with Matta's drawings, Breton invited the young artist to participate in the International Surrealist Exhibition of 1938 in Paris, and Matta remained affiliated with the Surrealist group until expelled by him in 1948. Matta continued to make important connections after relocating to New York in 1939, where he met several up-and-coming artists of the New York School, including Arshile Gorky, Robert Motherwell, Jackson Pollock, and Mark Rothko. He returned to Europe in 1948, seeking an environment better suited to his liberal political views.

Although Matta did not depict straightforward dream imagery, his explorations of automatism and biomorphism paralleled the interests of the Surrealists. An AMAM drawing created by Matta in 1948 (the year of his departure from New York and his expulsion from the Surrealist group) depicts the vaguely humanoid forms that became a signature characteristic of his work from the mid-twentieth century. The totemic quality of these figures was informed by the artist's interest in Pre-Columbian and Oceanic art objects, which he personally collected. The title of the work, inscribed by the artist in pencil at bottom center in partially illegible French, refers to a *Gynaeceum*—an ancient Greek term for the women's quarters of a house.

Matta began to devote himself to print media during the late 1950s, mastering a number of complex color printmaking techniques. The AMAM collection features three of Matta's works in color etching and aquatint. One derives from the series *Cosmicstrip* (1958), while the other two are from the 1962 series *Come detta dentro vo significado*, whose title quotes from Dante's *Purgatory*, part of his *Divine Comedy*. These prints recall Matta's painted "inscapes," which sought to represent the

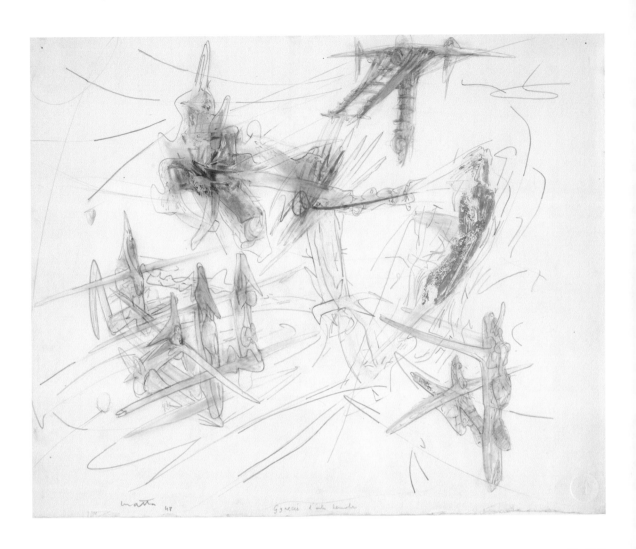

Untitled, from
*Come detta dentro
vo significado*

1962
Etching and aquatint
18 1/8 × 14 15/16 in.
Gift of Kenneth and Barbara
Watson, 2009.25.51
© 2014 Artists Rights Society
(ARS), New York / ADAGP, Paris

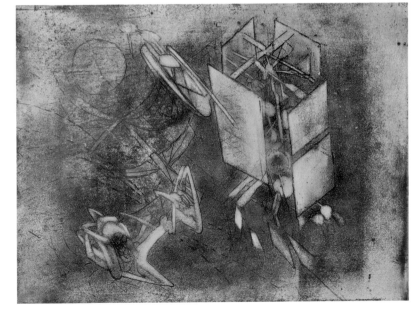

FIG. 2 Bernard Kirschenbaum (American, b. 1924), "Bernard Kirschenbaum Domes, Park Place Gallery," 1967. Offset lithograph poster, Allen Memorial Art Museum, I.9 A–B. © Bernard Kirschenbaum

Untitled

1968
Color etching and aquatint with hand touching
42½ × 42½ in.
Gift of Allan and Jean Frumkin, 2011.29
© 2014 Artists Rights Society (ARS), New York / ADAGP, Paris

interior space of the mind, and juxtaposed recognizable geometric shapes with more organic elements.

In a recent addition to the collection (*Untitled*, 1968), Matta expands his interest in form and spatial relationships with a composition based on a geodesic dome structure. Matta created his colorful, biomorphic forms within these geometric confines; when cut out and assembled (as per instructions illustrated on a poster for an exhibition by American architect Bernard Kirschenbaum at the Park Place Gallery in New York in 1967 [fig. 2]), Matta's dome evokes both macrocosmic and microcosmic universes. The few extant proofs of this rare, unpublished print were made at the Atelier Georges Visat in Paris in 1968, a time when Matta and many of his fellow artists were occupied with the political upheaval surrounding the student movement. The work came to the AMAM from Allan and Jean Frumkin. Allan was an early supporter of Matta in the United States, and the artist's representation at the Allan Frumkin Gallery in Chicago led to the popularity of Matta's works among Midwest collectors. In 2013, the Frumkin family also donated five pencil and crayon drawings on Wild West themes created by the artist around 1962 (see page 16).

Ana Mendieta American, born in Cuba, 1948–1985

Body Tracks

August 1974
Suite of five chromogenic prints
Each: 9½ × 7½ in.
Gift of Cristina Delgado
(OC 1980) and Stephen F.
Olsen (OC 1979), 2011.14.3
© The Estate of Ana Mendieta
Collection, Courtesy Galerie
Lelong, New York

In 1961, twelve-year-old Ana Mendieta left her native Cuba as part of Operation Peter Pan, an initiative to evacuate to the United States children of parents opposed to Fidel Castro's revolutionary government. Mendieta was relocated to Iowa, where she later began making her signature performance works while studying art at the University of Iowa under the tutelage of Hans Breder.

One such performance, *Body Tracks* (1974), is represented by two works in the AMAM collection, each comprising five color photographs that document the artist's action of smearing blood-red paint onto fabric affixed to the wall. The strokes created during the performance are recorded in the final product, while the prescribed action and reference to blood suggest a religious ritual. These works are related to Mendieta's *Silueta* (Silhouette) series made throughout the 1970s, which translates her ritualistic actions to the natural landscape. Impressing or tracing her body directly onto the earth, she then combined the resulting form with other primal elements such as fire, water, or blood to create ephemeral installations that survive through photographic documentation.

Similar to the strategies of many feminist artists working at the same time, Mendieta placed the female form at the center of her production, where she often imbued it with sacred connotations. Primordial female figures were the subject of Mendieta's *Rupestrian Sculptures* series created in Jaruco in 1981 on a return visit to Cuba. As evidenced in *Guanaroca*, Mendieta capitalized on the natural shapes of limestone rock formations in her carvings of rotund fertility figures named after

 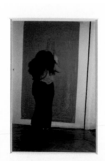 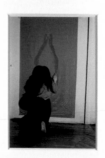 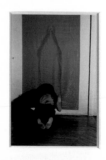 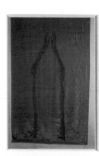

goddesses from the Caribbean Taíno culture, which she identified as part of her own ancestral heritage. The curvilinear contours of these earth-mother figures are echoed in an untitled wash drawing in the AMAM collection, one of many that Mendieta produced in a variety of media toward the end of her short career. As in *Body Tracks*, the drawing records the fluid movements of the artist's hand in the application of ink to paper.

The AMAM also has one work by the artist's sister, Raquelín Mendieta, who similarly worked in exile from her native Cuba and explored female imagery. Raquelín's work *KalyAni* (see page 19), in addition to the three photographic works by her sister Ana, were gifts to the museum from Cristina Delgado and Stephen F. Olsen.

Carlos Mérida Guatemalan, active Mexico, 1891–1984

Untitled

1934
Four lithographs
18½ × 12¹³⁄₁₆ in. (each)
Gift of Katharine Kuh,
1978.37.1–4
© Estate of Carlos Mérida

After hearing loss caused him to give up the piano at the age of fifteen, Carlos Mérida turned to the visual arts. He traveled to Paris in the 1910s and 20s, coming into contact with artists at the forefront of the avant-garde, among them Pablo Picasso, Amedeo Modigliani, Wassily Kandinsky, and Joan Miró. Returning to his native Guatemala, Mérida renewed his interest in the Pre-Columbian cultures of Latin America and applied the visual qualities of indigenous art to his own work. He continued to develop his approach to abstraction after relocating permanently to Mexico in 1919, creating paintings marked by geometric forms and flat areas of intense color. Mérida's style contrasted greatly with the social realism of the dominant Mexican School of the 1920s and 30s, with which he was briefly affiliated while collaborating with Diego Rivera on early mural projects. Mérida returned to the mural format later in his career, producing abstract compositions in mosaic and other materials, as opposed to the narrative frescoes of Rivera and his contemporaries.

In addition to painting, Mérida was an avid maker of prints. Four untitled lithographs in the AMAM collection, made in 1934, demonstrate his interest in abstraction as well as Surrealism, to which the artist had been exposed during his European sojourns. Each print has configurations of curved and straight lines that delineate such geometric forms as circles, triangles, crosses, and scrolls. These recognizable elements are juxtaposed with more ambiguous shapes, while blotchy areas of texture are scattered throughout. Despite the overall abstraction of the images, each maintains the suggestion of humanoid figures, resulting in a bizarre combination of the organic and the inorganic.

Guillermo Meza Mexican, 1917–1997

Nopalera

1946
Oil on paper
19⅝ × 25¾ in.
Charles F. Olney Fund, 1947.29
© Guillermo Meza

Guillermo Meza's *Nopalera* depicts a closely cropped image of a woman's face surrounded by prickly pear cacti, known as *nopales*. Native to Mexico, the edible *nopales* permeate both the country's landscape and its cuisine, and thus function as powerful national symbols. The term *nopalera* has a double meaning, signifying both the patch where the cacti grow as well as a woman who sells *nopales* to passersby on street corners in Mexico. Meza's painting does not show the *nopalera* in the midst of her trade (as would be in keeping with conventions in the representation of street types), but instead focuses on the woman's face, serving to individualize her as she gazes off into the distance with an air of dignity.

Situated at the center of the dense cactus patch, the *nopalera* almost seems to grow out of it herself. The shape of her face is mirrored by that of the cactus at right, with its round form and protruding nose-like element resembling a human face in profile. Most obviously, the hue of the woman's skin is similar to the green *nopales*, and even her hair seems to taper out into little points not unlike the brown spines on the surface of the cacti. The woman therefore appears as one with the cacti, suggesting a sense of unity between the Mexican landscape and its people, a notion popular in art of this period.

A Tlaxcalan Indian, Meza belonged to a group of young Mexican artists who emerged in the wake of the artistic dominance of *los tres grandes*: Diego Rivera, José Clemente Orozco, and David Alfaro Siqueiros. While continuing a dialogue with themes of *mexicanidad*, Meza introduced an element of mysticism to his personal style. This appealed to the European Surrealists, who included works by Meza alongside others by Rivera, Frida Kahlo, and Manuel Álvarez Bravo in their major International Surrealist Exhibition held in Mexico City in 1940.

Purchased in 1947 from the Galería de Arte Mexicana in Mexico City—the largest commercial venue for Mexican School works at the time—*Nopalera* is an early example of the museum's interest in collecting contemporary Latin American art.

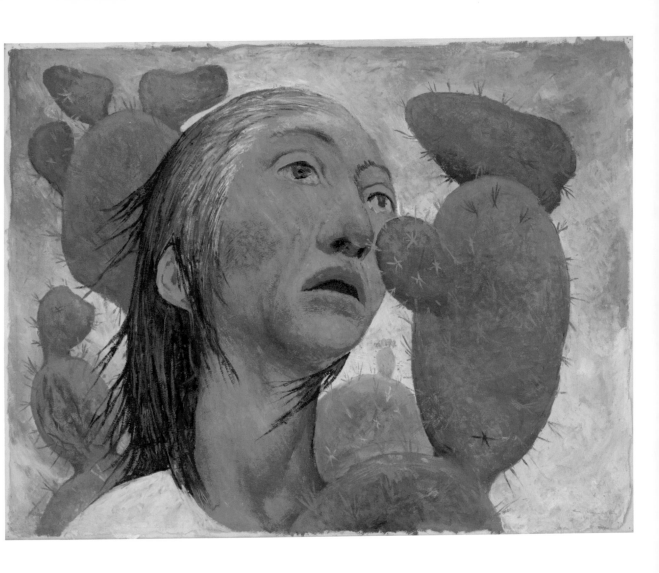

Vik Muniz Brazilian, b. 1961

Valicia Bathes in Sunday Clothes, from the series *Sugar Children*

1996
Gelatin silver print
14 × 11 in.
Gift of Anne and Joel
Ehrenkranz, 2013.68.5
Art@Vik Muniz / Licensed by
VAGA, New York, NY

Vik Muniz was born in São Paulo and immigrated to New York in 1983. His artistic vision seeks to transform the mundane: he painstakingly arranges such diverse materials as trash, chocolate syrup, diamonds, and thread to create highly illusionistic images. Muniz then photographs the resulting compositions from above, producing a *trompe l'oeil* effect.

Valicia Bathes in Sunday Clothes stems from one of the artist's earliest experiments with photographing transformed materials. For the *Sugar Children* series, first exhibited at the Museum of Modern Art in 1997, Muniz worked from Polaroid images to recreate the likeness of his subjects in sugar on a black background. The titles of the photographs reveal Muniz's intimate relationship with the subjects, as they relate the name of each child as well as a personal detail about his or her life, such as *Big James Sweats Buckets* or *Little Calist Can't Swim*. The children come from families who work on sugar cane plantations on the Caribbean island of Saint Kitts. Muniz chose to fabricate his *Sugar Children* from the very commodity they labor to produce: "I realized they take the sweetness out of the children by making them work in the fields. It's very hard work. All the sweetness from them ends up in our coffee. So I made drawings of them from sugar."

A second Muniz work given to the AMAM by Anne and Joel Ehrenkranz, *Untitled (Medusa Plate)*, was produced as the Peter Norton Family Christmas Project gift for 1999. The plate features a pasta marinara rendition of Caravaggio's round-format painting *Medusa* (ca. 1597, Uffizi, Florence).

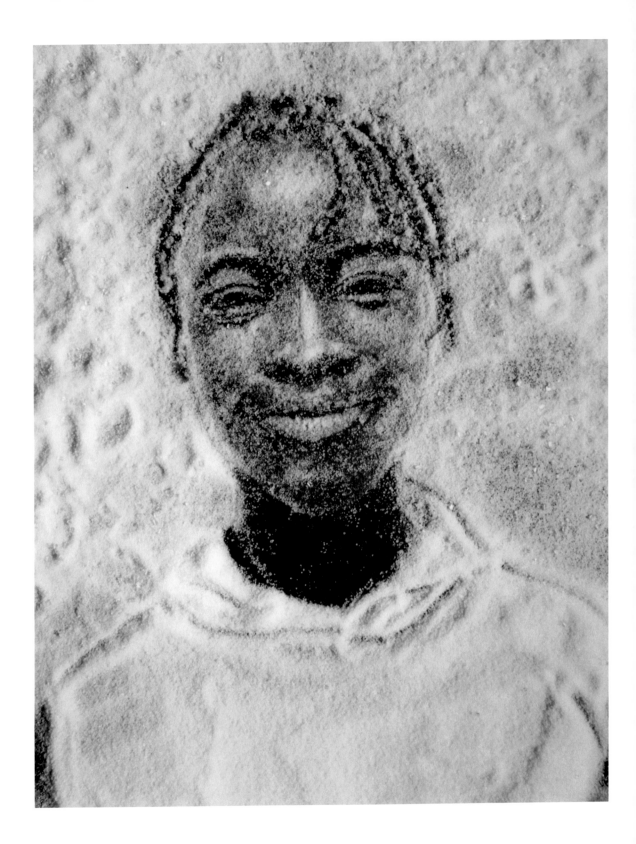

Ernesto Neto Brazilian, b. 1964

Untitled

1995
Construction paper, black
thread, wax, and lead
Paper: 13 × 19⅜ in.
Gift of Cristina Delgado
(OC 1980) and Stephen F.
Olsen (OC 1979), 2004.13.6
Courtesy the artist and Tanya
Bonakdar Gallery, New York

Born in Rio de Janeiro, Ernesto Neto is recognized across the globe for his monu-
mental sculptural installations. These room-size, often enterable environments are
typically comprised of suspended, biomorphic elements created from weighted
fabric, whose form is dictated by the forces of gravity and balance.

The AMAM's untitled work translates to a much more intimate scale Neto's
interest in natural phenomena and the tactile quality of his materials. In this
tabletop installation, Neto sandwiches a piece of thread between two sheets of
construction paper, fixed together with wax. A length of each end of the thread
extends beyond the paper and is attached to a small lead weight. The resulting
composition may be arranged in a number of configurations that rely on the pre-
carious tension of the weighted strings to remain upright. Part collage and part
sculpture, the hybrid work is perhaps best described as a three-dimensional draw-
ing; the thread trapped between the translucent layers of the waxed paper reads
as a pencil line, which extends into space in the form of the straight vectors culmi-
nating in the lead endpoints. An extra length of string with no supporting function
may be arranged freely, suggesting a spontaneous squiggle. Classified by Neto as
"almost drawings," constructions similar to the AMAM work were first exhibited at
the Sergio Porto Cultural Center in Rio de Janeiro in 1993.

Gabriel Orozco Mexican, b. 1962

*Extensión del reflejo
(Extension of Reflection)*

1992
Silver dye bleach print
Image: 15$\frac{15}{16}$ × 19$\frac{1}{8}$ in.
Gift of Cristina Delgado
(OC 1980) and Stephen F.
Olsen (OC 1979), 2002.21.3
© Gabriel Orozco

*Pelota en el agua
(Ball on Water)*

1994
Silver dye bleach print
Image: 12$\frac{1}{2}$ × 18$\frac{3}{4}$ in.
Gift of Cristina Delgado
(OC 1980) and Stephen F.
Olsen (OC 1979), 2002.21.2
© Gabriel Orozco

Extension of Reflection functions as both documentation of an ephemeral action and as a final work of art in itself. By repeatedly riding his bicycle through puddles of water, Gabriel Orozco inscribed a circular shape onto the surface of the pavement and effectively made a drawing using bicycle tires and water as brush and ink.

Extension of Reflection is one of six Orozco photographs given to the AMAM by Cristina Delgado and Stephen F. Olsen. Since he began photographing his native Mexico City in the mid-1980s, Orozco has focused on the interrelationship between documentation and action, inspired by and executed within his immediate environment. In daily strolls about the city, Orozco captures with his camera the sights and scenes that catch his interest, which are often inanimate objects. In isolating these phenomena through his lens, Orozco highlights their morphological qualities, granting the everyday objects an elevated status. His deadpan approach and straight-on views serve to estrange his objects, which become "incidental sculptures" found in nature. In *Ball on Water*, for example, a white ball floating in a puddle resembles a glowing celestial orb. Ordinary objects figure prominently in four other AMAM photographs by Orozco, for example a paned window, a green telephone receiver hooked onto a door handle, a tiny toy deer placed on the edge of a kitchen sink, and a pay phone on a street corner (see page 15).

José Clemente Orozco Mexican, 1883–1949

La Bandera (The Flag)

1928
Lithograph
16 × 22¹³⁄₁₆ in.
Gift of Leona E. Prasse from the
Mr. and Mrs. Charles G. Prasse
Collection in honor of Ellen H.
Johnson, 1977.90
© 2014 Artists Rights Society
(ARS), New York / SOMAAP,
Mexico City

Three Generations

1926
Lithograph
15⅞ × 22¾ in.
Gift of Leona E. Prasse from the
Mr. and Mrs. Charles G. Prasse
Collection in honor of Ellen H.
Johnson, 1977.89
© 2014 Artists Rights Society
(ARS), New York / SOMAAP,
Mexico City

The first painting by a Latin American artist to enter the AMAM collection, José Clemente Orozco's *Mexican House* depicts a square, mud-colored structure in a sparse landscape with an ink black sky (see page 20). In the left foreground, the spiny fronds of a maguey cactus, a traditional symbol of Mexico, lend specificity to the otherwise austere setting. Lacking a human presence but peopled by ambiguous geometric shapes, the composition evokes a sense of timelessness.

Mexican House is typical of Orozco's style of the 1920s and 30s, noted for its monumental forms and bleak overtones. Like his contemporaries Diego Rivera and David Alfaro Siqueiros, Orozco explored many of the same motifs in easel paintings and works on paper as he did in large-scale murals. *Three Generations* and *Marching Women*, for example, two of seven Orozco lithographs in the AMAM collection, relate to panels from his mural cycle for the courtyard at the National Preparatory School in Mexico City, executed between 1923 and 1926. The lithographs are thematically linked to decorations on the courtyard's third floor, which present somber scenes of leave-taking and preparation for battle. The stark form of the house reappears at the center of *Marching Women* (see page 23), as soldiers—rifles slung over their shoulders and sombrero-sporting heads bowed in resignation—depart from their loved ones. A foil to the women on the left of the composition, two *soldaderas* (female companions and fighters) join the revolutionary cause.

Gender roles also permeate *The Flag*, which juxtaposes the figure of a pregnant woman, representing family, with the backs of the retreating male soldiers. The train car in the background alludes to the common method of transporting soldiers during the Mexican Revolution, while the flag denotes patriotic dedication to the cause. Like *Marching Women*, this lithograph, made during Orozco's relocation to the United States between 1927 and 1934, was created after an earlier work, a drawing from his *Horrors of Revolution* series (1926). Similar to Francisco de Goya's famous series *Disasters of War*, Orozco's works chronicled atrocities committed during the Mexican Revolution. Orozco subsequently produced a suite of lithographs based on some of the less violent compositions from *Horrors of Revolution*—including the AMAM's *The Flag*, *Rear Guard*, and *Ruined House*—and marketed them to a United States audience.

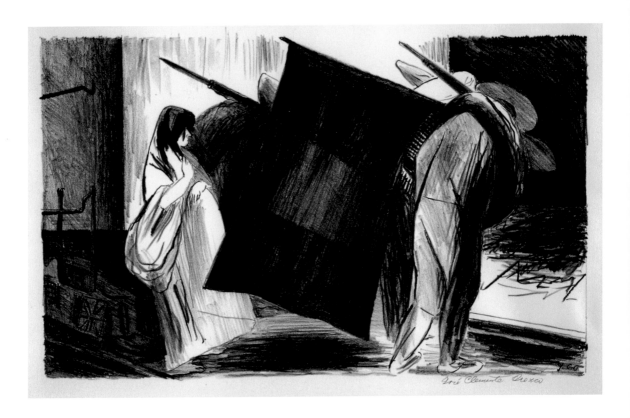

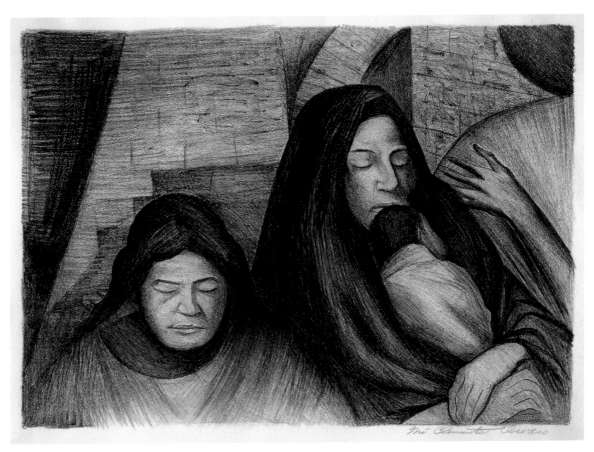

Pepón Osorio American, born in Puerto Rico, 1955

Born in Puerto Rico, Pepón Osorio lived and worked in New York for several years before relocating to Philadelphia. His experience as a Latino immigrant informs his kitschy, often large-scale assemblages of symbolically loaded cultural artifacts and found objects. These lively, colorful installations address such serious matters as race, poverty, death, and violence with an air of playfulness and humor. Osorio applies his background as a social worker to his artistic practice, which often entails his immersion into a community to learn about its particular values and issues. The artist involves local individuals in his art projects: according to Osorio, his "principal commitment as an artist is to return art to the community."

Inspiration for *Tina's House* came from the story of a Philadelphia woman, Tina Rosado, and her two daughters, who lost everything in a house fire. Osorio collaborated with the family directly, incorporating a number of their personal photographs and possessions into the dollhouse-like object. The tabletop sculpture recreates the condition of the family's home in the aftermath of the fire; precariously stacked piles of miniature objects fill the interior, including upturned furniture, picture frames, food and household products, Barbie dolls and other

toys, and a working chandelier. Many of the items are half submerged in transparent resin at ground level, suggesting a flood. Images of butterflies and Osorio's self-portrait decorate the removable roof of the structure, while dolls representing Tina and her children occupy the snow-covered yard, complete with a white picket fence behind the house. Amid the chaos of the interior is a figurine of the Virgin of Guadalupe, a popular religious icon in many Latin American countries (see detail). The presence of the Virgin corroborates Osorio's intentions of helping the family to restore their faith after the tragedy, aiding them in the healing process.

Tina's House was one of several works in Osorio's *Home Visits* series, which traveled to different private residences. Individuals without the means to collect art had the opportunity to interact with the works for a period of one week in their own homes, rather than in a gallery setting. This practice also recalls the Puerto Rican tradition of the visiting saint, in which religious icons are borrowed from a church for short-term private devotion in one's home.

Cleveland-based labor attorney Esther S. Weissman, whose defense of workers' rights parallels Osorio's own social concerns, donated *Tina's House* to the AMAM. Before entering the collection, the work was profiled extensively in the premiere episode of *Art:21*, a public-television documentary series.

Adolfo Patiño Torres Mexican, 1954–2005

Triángulo místico

1983
Cut rulers, paper cutouts, wood, paint, and acrylic
10 7/16 × 12 × 7/8 in.
Gift of Edward J. Sullivan in honor of Denise Birkhofer, 2013.28
© Adolfo Patiño Torres

The photographs, mixed-media works, and performances of Adolfo Patiño Torres are deeply indebted to the culture of his native Mexico City. After completing his studies at the Universidad Nacional Autónoma de México, the young Patiño founded two artist collectives: Peyote and Company (active 1974–84), which collaborated on film, installation, and performance works; and the Independent Photographers Group (active 1976–84), which focused on photography.

In the mid-1980s, Patiño turned his attentions to his solo career, producing assemblage works such as *Triángulo místico* (Mystic Triangle), constructed from rulers and collaged fragments of *lotería* cards, including three hands, three crescent moons, and a red sun. Dating back to the colonial period, when the Spanish brought printed games to the New World, *lotería* is a popular game with a board and deck of cards featuring symbolic figures or objects. Along with other loaded symbols of Mexican history and culture—the Mexican flag, the Virgin of Guadalupe, and the maguey cactus—*lotería* cards became a common reference for artists engaged with Neo-Mexicanism. Prevalent in the 1980s and into the 90s, Neo-Mexicanism recycled national iconography in order to reinterpret or question fixed notions of Mexican identity, often in a satirical fashion.

Like the *lotería* cards, rulers were also a recurrent motif in Patiño's oeuvre, most notably in his series *Marcos de referencia* (Frames of Reference), to which *Mystic Triangle* belongs. These mixed-media works often combined objects of personal significance to Patiño—family photographs, childhood clothing, or even X-ray films of his own body—with Neo-Mexicanist elements, all separated from the space of everyday life by the ruler frame. Patiño took full advantage of the wordplay implied by the word *regla*, which translates from Spanish to both "rule" and "ruler." In a seminal performance of the 1980s, *Hay que romper las reglas* (One Must Break the Rules / Rulers), Patiño raised a bottle of Coca-Cola in salute to the Virgin and asked the audience to join him in breaking a ruler (i.e. breaking the rules).

Although his works have yet to receive significant attention in the United States, in the late 1980s the Metropolitan Museum of Art acquired two works by Patiño from his ruler-framed series. At about this time, Patiño gave *Mystic Triangle* to his friend Edward J. Sullivan, professor of Latin American art history at New York University, who in 2013 donated the work to the AMAM.

Liliana Porter Argentine, b. 1941

Brancusi

2008
Duraflex photograph
11 × 15¼ in.
Ruth C. Roush Contemporary
Art Fund, 2013.4
© Liliana Porter

Born in Buenos Aires and trained in Mexico City, Liliana Porter relocated to New York City in 1964. Soon upon her arrival, she co-founded the New York Graphic Workshop (1965–73) along with fellow émigrés José Guillermo Castillo from Venezuela and Luis Camnitzer from Uruguay. Together they taught printmaking and experimented with alternative means of making and distributing art, focusing on the production of multiples. During this period, Porter began a series of works based on the wrinkling of paper, a technique by which the artist's actions transform a blank sheet of paper or make it nearly disappear. She extended these investigations to a grand scale, covering room-sized installations with wrinkled paper, as well as to more intimate works.

Wrinkle derives from a related portfolio of ten photo-etchings produced by Porter at the Graphic Workshop in 1968. As the series progresses, a blank sheet of paper is increasingly crumpled up into a small ball at the edge of the page. The AMAM work, an artist's proof of the seventh image in the series, is rotated 90 degrees counter-clockwise from the published edition, which is presented in a horizontal format. *Wrinkle*'s straightforward images function both as formal studies of the paper as well as records of the artist's repeated manipulations.

In the works for which she is most known, Porter continues her minute interventions on objects. In paintings, prints, photographs, and videos, Porter composes still-life arrangements of small items that she personally collects, such as toys, figurines, and other knickknacks. She monumentalizes these objects by isolating them within an empty white background, reminiscent of the blankness of the sheet of paper in *Wrinkle*. The little toys, many of which possess an uncanny anthropomorphic quality, form witty juxtapositions with one another. In *Brancusi*, for example, a pink stone bird gazes at an image of a marble egg, as though contemplating its own origins. Porter frequently incorporates reproductions of other artists' works in her images, such as this postcard depicting Constantin Brancusi's *Sculpture for the Blind*. The bird ornament further references Brancusi's series of sleek *Bird in Space* sculptures, which the Romanian artist produced beginning in 1923. Porter often extends her playful reverence to other art historical figures for whom she has great respect, such as Belgian Surrealist René Magritte, whose treatment of objects as signifiers parallels Porter's own approach to her inanimate subject matter.

Wrinkle

1968
Photo-etching
16 × 13¼ in.
Anonymous Gift, 1985.37
© Liliana Porter

René Portocarrero Cuban, 1912–1986

Señales No. 2

1952
Tempera and ink
14$\frac{15}{16}$ × 10$\frac{15}{16}$ in.
Gift of Mr. Joseph Cantor, 1956.7
© René Portocarrero

The eclectic architecture of Old Havana served as a source of artistic inspiration for Cuban artist René Portocarrero. Like his compatriot Amelia Peláez, Portocarrero responded to the various architectural traditions of his native city, which range from Cuban Baroque to Art Deco. Made at the height of Portocarrero's most abstract period, *Señales No. 2* features black, criss-crossed lines that evoke wrought-iron gates and lattices, while planes of color suggest stained-glass windows. Known for his vibrant use of color, here Portocarrero mutes his palette with tempera washes in green, brown, and blue, accented by areas of highly saturated lemon yellow and earthy red.

The composition is a complex configuration of spirals, triangles, circles, dots, hatchmarks, and parallel lines. Despite the emphasis on geometry, the arrangement reads as an upright totemic figure: a triangular head punctuated by two eyes is discernible at top center. Portocarrero often constructed human forms from geometric shapes, particularly triangles. The figure in this work may relate to Portocarrero's representations of Caribbean popular and religious practices, such as Carnival or Afro-Cuban traditions, the latter also an interest of fellow Cuban artist Wifredo Lam.

A second work of mid-twentieth-century Cuban abstraction in the AMAM collection is the 1952 ink and wash drawing *Composition* by Raul Milian (see page 14), a student of Portocarrero; both works were gifts of Joseph Cantor, an Indianapolis-based business owner and collector of modern art, including important works by Lam.

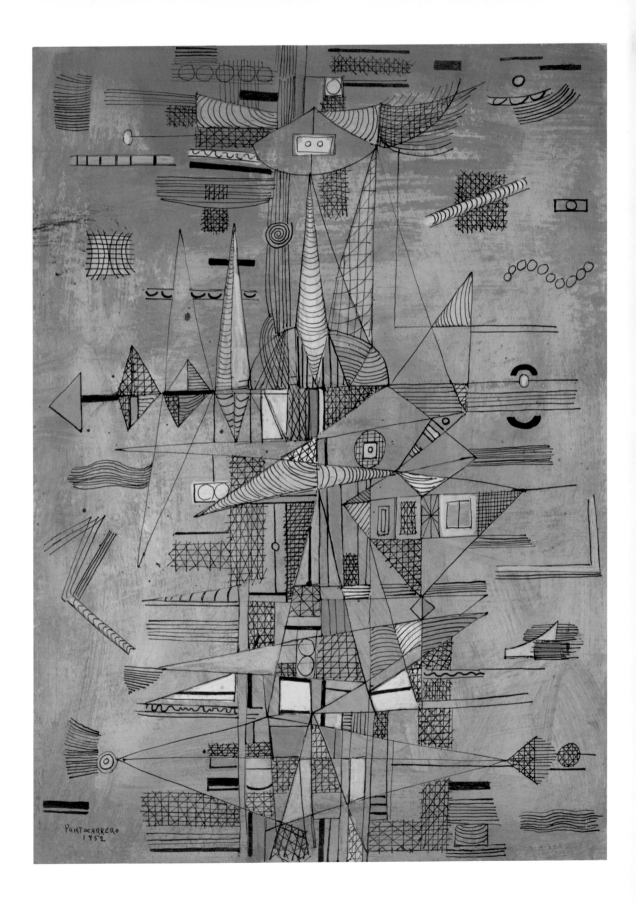

Miguel Rio Branco Brazilian, b. 1946

Galo de Briga
1984
Cibachrome print
24 × 35½ in.
Gift of Cristina Delgado
(OC 1980) and Stephen F.
Olsen (OC 1979), 2013.62.2
© Miguel Rio Branco

The first example of Brazilian photography to enter the AMAM collection, *Galo de Briga* depicts a fighting cock in Miguel Rio Branco's signature saturated colors. A member of the international artist cooperative Magnum Photos, Rio Branco is known for compelling photographs that document life in his native country.

Reproduced in his award-winning book *Nakta*, published in 1996, *Galo de Briga* was taken in Salvador da Bahia, a city that Rio Branco has photographed for many years. Rather than capturing the action of a cockfight, the photograph instead presents the aftermath, focusing on the visibly wounded back of the rooster. Many of Rio Branco's other images reveal a similar preoccupation with wounds and scars, in both animal and human subjects. These references to violence and suffering lend a visceral quality to his vibrantly hued works, which are simultaneously alluring and unpleasant.

Galo de Briga's formal devices lend the rooster an anthropomorphic quality. Presenting only the back of the animal, the ground-level viewpoint serves to monumentalize the bird's figure. The rooster is further humanized through linguistic associations between the Portuguese word *galo* and the concept of *machismo*, which liken the fighting cock to socially conscribed notions of manliness.

Diego Rivera Mexican, 1886–1957

Self-Portrait

1930
Lithograph
18⅝ × 13¾ in.
Gift of Mrs. Malcolm L. McBride,
1941.29
© 2014 Banco de México Diego
Rivera Frida Kahlo Museums
Trust, Mexico, D.F. / Artists
Rights Society (ARS), New York

One of the most recognizable figures of Mexican Modernism, Diego Rivera trained in Europe, where he experimented with Cubism in Paris from 1913 to 1916 and studied Italian Renaissance frescoes in 1921. Upon his return to Mexico, Rivera applied these lessons to projects that included large public murals. Funded primarily by the Mexican government, such murals were meant to demonstrate the legitimacy and efficacy of post-Revolutionary society, communicated to the public in a monumental and accessible format.

The lithograph *Fruits of Labor* derives from the mural panel *Fruits of the Earth*, located in Rivera's cycle at the Ministry of Public Education, executed between 1923 and 1929. Both depict a female teacher distributing apples to a crowd, symbolizing the dissemination of knowledge as suggested by the open book nearby. The rectangular composition of the lithograph cuts off the rounded top of the original

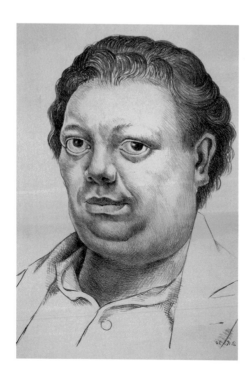

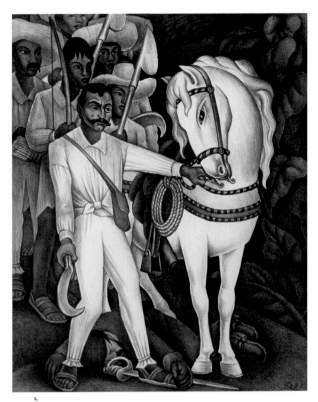 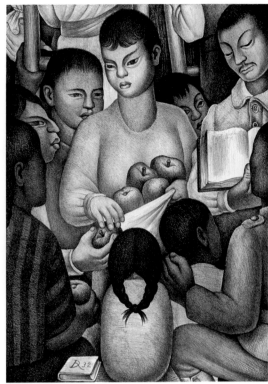

Emiliano Zapata

1932
Lithograph
22¹¹⁄₁₆ × 15¹³⁄₁₆ in.
Gift of Leona E. Prasse from the
Mr. and Mrs. Charles G. Prasse
Collection in honor of Ellen H.
Johnson, 1977.93
© 2014 Banco de México Diego
Rivera Frida Kahlo Museums
Trust, Mexico, D.F. / Artists
Rights Society (ARS), New York

The Fruits of Labor

1932
Lithograph
20⅞ × 14¹⁵⁄₁₆ in.
Gift of Leona E. Prasse from the
Mr. and Mrs. Charles G. Prasse
Collection in honor of Ellen H.
Johnson, 1978.50
© 2014 Banco de México Diego
Rivera Frida Kahlo Museums
Trust, Mexico, D.F. / Artists
Rights Society (ARS), New York

mural panel's window, above which a red-painted banner proclaims, "Blessed is the tree that yields ripe fruits, it is worth much more than a mountain of *pesos*."

A second lithograph in the AMAM collection, *Emiliano Zapata*, is likewise derived from a panel titled *The Revolt* from Rivera's mural cycle at the Palacio de Cortes, completed in 1930. As an endpoint to the cycle's narrative, which chronicles the history of the Cuernavaca region, the Christ-like figure of Zapata leads agrarian laborers to revolution.

Of all his Mexican contemporaries, Rivera witnessed the most success in the United States. In 1932, he became only the second individual artist featured in a retrospective at New York's Museum of Modern Art, following Henri Matisse. Rivera also received major mural commissions throughout the 1930s from such American institutions as the San Francisco Stock Exchange, the Detroit Institute of Arts, and Rockefeller Center. The artist likewise took advantage of the lucrative market that developed for his easel paintings and works on paper among American collectors, who were attracted to Rivera's style and subject matter. His focus on Mexico's popular culture and Pre-Columbian heritage is apparent in the watercolor *Portrait of a Girl* (see page 10), the second work by a Latin American artist purchased by the AMAM, which depicts a barefoot girl in traditional indigenous dress.

The six works by Rivera in the AMAM collection include three additional lithographs: *Open-Air School* (see page 22), *Young Boy Eating*, and *Self-Portrait*. Acquired in 1941, the artist's self-portrait was the first Latin American work ever given to the museum.

Arnaldo Roche-Rabell Puerto Rican, b. 1955

Born in Santurce, Puerto Rico, Arnaldo Roche-Rabell relocated to the United States in 1979, where he studied at the Art Institute of Chicago. Roche's Caribbean heritage remains central to his work, as reflected in his use of color and in his self-identification as an "island man," which he asserted in many pseudo self-portraits. Like Cuban artist Wifredo Lam, Roche imbues his compositions with spiritualism and evocations of the power of nature.

In *Man in the Dark*, a male figure against a dark background seems to merge with nature itself, his fingers morphing into long, branchlike appendages, his skin rendered in a rough texture reminiscent of tree bark. A glowing halo surrounding the figure's head suggests a religious icon, while the title implies a trying psychological or spiritual state. The apparent suffering of the man, whose isolated body is captured in a state of petrification, contributes to Roche's self-presentation as a Jesus-like figure.

Roche's painting technique contributes to the emotionalism of the composition. On the surface of the large-scale canvas, he has applied multiple layers of oil paint to create a thick impasto. The inky black upper layers are partially scratched away, in a technique known as grattage, to reveal the fiery reds and yellows underneath that cause the figure to glow as though from an inner light. Roche's use of vibrant color and lively, textured surfaces are qualities typically ascribed to Neo-Expressionism, as is the artist's supposed transference of personal emotions to the work during its creation.

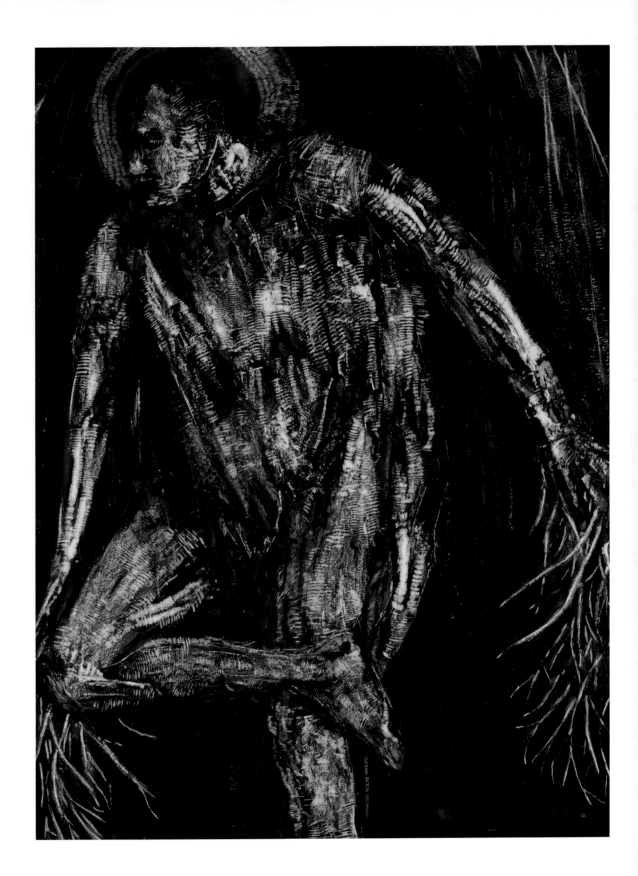

Artemio Rodriguez Mexican, b. 1972

Born in the small town of Tacámbaro, Mexico, Artemio Rodriguez works in a variety of media but is best known for his masterful woodcuts. He entered the United States at age twenty-one and in 2002 founded La Mano Press, a printmaking center in Los Angeles. Rodriguez draws on numerous references to both Mexican and American culture, including Catholicism, Mexican folk tradition, American society, and the Western art historical canon.

Produced as an edition of ten, *The Triumph of Death* is a monumental *tour de force* of the woodcut technique, carved into birch plywood with impressive attention to detail. The work is divided into nine panels that together measure 8 feet tall by 12 feet wide. Rodriguez's dynamic composition is based on a painting of the same name by Pieter Bruegel the Elder (ca. 1562, Museo del Prado), which depicts an army of skeletons descending on a besieged landscape and torturing its human inhabitants; kings and peasants alike fall at Death's hands. In recreating a well-known painting, Rodriguez refers to the pre-photographic role of printmaking for art reproduction. Rather than a direct copy, however, Rodriguez's version of *The Triumph of Death* includes such contemporary elements as bellowing industrial smokestacks and an atomic mushroom cloud; figures clothed in cowboy boots, sports jerseys, a sombrero, and a KISS T-shirt; and various other objects of modern life, including a pickup truck, barrel of oil, soccer ball, milk cartons, and an ATM. While images of skeletons and death pervade Mexican visual art, as exemplified by the satirical *calaveras* of graphic artist José Guadalupe Posada or the imagery associated with Day of the Dead celebrations, Rodriguez's citation of Bruegel is a reminder that images of death pervade European art as well.

The AMAM has a second large woodcut by Rodriguez titled *One God, One City, One Woman (Beauty is not Always Perfect)* from 2002; both works were gifts of Michael and Driek Zirinsky.

Doris Salcedo Colombian, b. 1958

Untitled
(with detail)

1989–1993
Shirts, gesso, and steel rebars
66¾ × 10⅛ × 15⅛ in.
Gift of Cristina Delgado
(OC 1980) and Stephen F.
Olsen (OC 1979), 2002.21.1
© Doris Salcedo

Doris Salcedo's installations often incorporate articles of clothing and other domestic objects recovered from victims of political violence in her native Colombia. Growing up, she was witness to political instability—a guerrilla occupation of Bogotá's Palace of Justice in 1985 that resulted in the deaths of 126 people, including the entire Supreme Court—as well as the routine disappearance of individuals deemed threatening to the government order. While often responding to the experiences of individual victims and their surviving families, Salcedo also addresses universal themes of violence and the human condition.

This untitled work, comprising a stack of plastered white shirts speared by three black metal rebars, was created in response to the 1988 mass murder of male workers at a banana plantation in Colombia. Similar to the white work shirts the plantation workers would have worn, the garments stand in for the murdered men. The piercing of the shirts with rebars symbolizes the violence of their deaths. The stack of shirts also resembles a spindle on which receipts or other papers are filed, perhaps an allusion to the vast quantity of mass death.

Originally shown in 1989 at the Galería Garcés Velásquez, the AMAM work was installed alongside several other stacks of plastered shirts of various heights, as well as metal bed frames wrapped in animal skins, lying on the floor or leaning up against the wall (fig. 3). The bed frames recalled how the plantation workers were dragged from their beds in the middle of the night and murdered in front of their families. One of Salcedo's first projects to incorporate clothing, this installation marked a turning point in her body of work as she increasingly began to use clothing as her primary material. Presently the sole example by a Colombian artist in the AMAM collection, the Salcedo sculpture came to Oberlin from Cristina Delgado and Stephen F. Olsen.

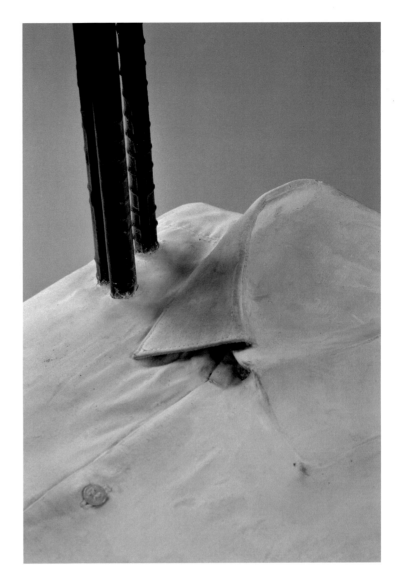

Fig. 3 Installation view, Galería
Garcés Velásquez, Bogotá,
1989–90.

Andres Serrano American, b. 1950

Andres Serrano was born in New York City to a Honduran father and an Afro-Cuban mother. He became interested in photography while attending the Brooklyn Museum School at the age of seventeen, but did not pursue art seriously until the late 1970s after recovering from a drug addiction. Serrano began to make provocative works that address such hot-button issues as race, religion, and sex. In 1989, Serrano's works, and specifically his *Piss Christ* (a photograph of a crucifix submerged in a glowing gold haze of urine), attracted the ire of the U.S. Senate and, along with works by photographer Robert Mapplethorpe, became the center of a heated debate on federal funding of the arts.

Serrano's focus on bodily fluids as a subject meshes his interests in the corporeal and the spiritual. Although *Ejaculate in Trajectory* first appears to be a nearly abstract representation of an arc of light, it in fact depicts the artist's own semen captured in midstream against a black background. *Blood and Semen V* likewise presents a close-up image of bodily fluids in an overtly aesthetic composition, taking advantage of the color printing process to deliver a saturated red.

Blood and Semen V is one of eleven photographs included in the portfolio *In a Dream You Saw a Way to Survive and You Were Full of Joy*, produced in 1990 by Photographers & Friends United Against AIDS. The portfolio, which also includes Alfredo Jaar's *Untitled* (see page 55), features many works that demonstrate an explicit awareness of the AIDS crisis, as indicated by Serrano's depiction of the bodily fluids most likely to transmit the disease. Both *Ejaculate in Trajectory* and *Blood and Semen V*, purchased by the AMAM soon after their creation, allude not only to AIDS and sexuality, but also to Serrano's lapsed Catholicism, whose doctrine attests to the spiritual power of corporeal fluids.

A third Serrano work in the AMAM collection tackles another controversial subject. *Klansman (Knighthawk of Georgia, V)* stems from a 1990 series of portraits of Ku Klux Klan members. Although each sitter is identified by his codename in the title, an iconic hood provides anonymity. In the AMAM image, a Klansman is presented in profile, his white hood isolated against the black background in a formal manner similar to Serrano's other compositions. Although Serrano's choice of subject seems unorthodox, especially given his African heritage, his formalizing approach serves to dehumanize and abstract the politically charged sitter.

Klansman (Knighthawk of Georgia, V)

1990
Cibachrome print
30⅛ × 23⅞ in.
Art Rental Collection Transfer,
2009.9
© Andres Serrano

David Alfaro Siqueiros Mexican, 1896–1974

Emiliano Zapata

1926
Lithograph
31¾ × 22¹⁄₁₆ in.
Gift of Leona E. Prasse from the
Mr. and Mrs. Charles G. Prasse
Collection in honor of Ellen H.
Johnson, 1978.51
© 2014 Artists Rights Society
(ARS), New York / SOMAAP,
Mexico City

Like Diego Rivera and José Clemente Orozco, David Alfaro Siqueiros was active as a muralist in the post-Revolutionary years in Mexico. Setting Siqueiros apart from his colleagues, however, was his fervent politicism: while all three of the *tres grandes* were invested in social and political issues, Siqueiros was an active member of the Communist Party of Mexico, and this ideology often permeated his art. Siqueiros's beliefs about the relationship of art and politics were codified in the *Manifesto of the Syndicate of Technical Workers, Painters, and Sculptors*, which he wrote in 1924. This text declared the social responsibility of art and likened the role of artists to that of collective laborers; it aligned their cause with the working class as opposed to the bourgeoisie.

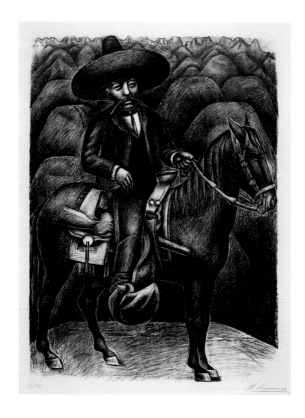

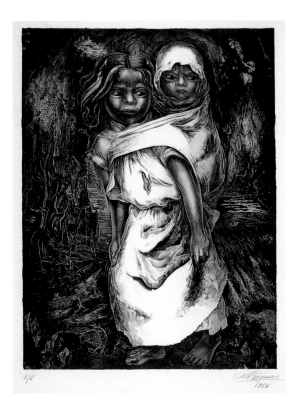

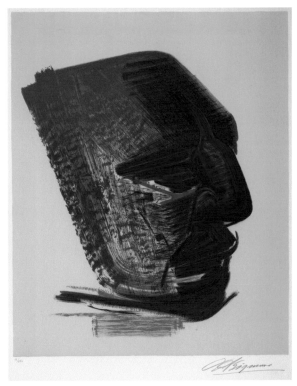

*Niña madre
(Child Mother)*

1956
Lithograph
33¹¹⁄₁₆ × 25⅛ in.
Gift of Mr. and Mrs. Paul Seligson in honor of their daughter, Judy Seligson (OC 1981),
1977.78
© 2014 Artists Rights Society
(ARS), New York / SOMAAP,
Mexico City

*Máscara (Mask),
from the series
Mountain Suite*

1969
Color lithograph
25½ × 19¹¹⁄₁₆ in.
Gift of Thomas G. Campbell
(OC 1955), 1974.74
© 2014 Artists Rights Society
(ARS), New York / SOMAAP,
Mexico City

Siqueiros's political sympathies are apparent in his choice of subject matter for *Emiliano Zapata*, which depicts the leader of the Mexican Revolution and champion of land reform on horseback, sporting his characteristic sombrero and mustache. Although Zapata had been assassinated in 1919, in Siqueiros's composition of several years later the leader appears to relish the fruits of his efforts, the contours of his figure in peaceful harmony with the surrounding landscape of rolling mountains.

Active for nearly 20 years longer than either Rivera or Orozco, Siqueiros carried the concerns of the Mexican School into the 1970s, remaining a strong presence for subsequent generations of artists in Mexico. In works like the AMAM's *Child Mother* and *Mask*, Siqueiros continues to address themes related to the legacy of the Mexican Revolution, such as peasant life, family, and Mexico's Pre-Columbian heritage.

In contrast to the persistent realism of such subjects, Siqueiros also made a profound impact on the development of abstraction in the United States and Mexico. For example, in his 1936 Experimental Workshop in New York, Siqueiros instructed participants—future abstract expressionist Jackson Pollock among them—in the use of the airbrush and industrial paints, which were innovative techniques at the time. *Child Mother* recreates the composition of a 1936 painting in the collection of the Santa Barbara Museum of Art, executed in Siqueiros's signature pyroxylin paint applied with a spray gun. Both are based on an early-twentieth-century photograph of an indigenous girl carrying a baby on her back, by German photographer Hugo Brehme.

Fernando de Szyszlo Peruvian, b. 1925

*The Execution of
Túpac Amaru*

1966
Oil on canvas
59¼ × 59 in.
Gift of Norman and Jean Moore
(OC 1938), 2007.25
© Fernando de Szyszlo

Born in Lima to a Peruvian mother and Polish father, Fernando de Szyszlo studied painting at the Pontifical Catholic University of Peru. He traveled to Europe at age 24, where he studied the techniques of such masters as Rembrandt and Titian and made contact with avant-garde artists associated with Cubism and Surrealism. Returning to Peru, Szyszlo began to approach Pre-Columbian history and Peruvian culture with a language of lyrical abstraction. A pioneer of non-objective art in Peru, Szyszlo belonged to a generation of artists from the Americas who pursued abstraction as a means to assert a cultural identity that differed from Western traditions. Unlike the flat planes of color preferred by such northern contemporaries as Mark Rothko, Szyszlo created highly modulated surfaces through the use of suggestive shading and punctuations of thick impasto. Moreover, his color palette and forms are symbolically tied to native Peruvian sources.

The Execution of Túpac Amaru belongs to a series completed in the mid-1960s. The last indigenous Incan monarch in Peru, Túpac Amaru (1545–1572), was publicly beheaded by the viceregal government after being falsely accused of the murder of a group of Catholic priests. For Szyszlo, Túpac Amaru represents the struggle for Peruvian independence from Spanish colonial rule. Rather than literally illustrate the moment of the Incan leader's death, Szyszlo alludes to the tragic event through his expressive use of color. The somber black that dominates the composition and the accents of vibrant pink, red, and yellow suggest violence and death. The circular disk, a recurrent motif in Szyszlo's art, symbolizes a sun, a reference to the self-identification of the Incas as "Children of the Sun." As king, Túpac Amaru would have functioned as the extension of the sovereignty of the Sun-God on earth; thus the dark orb represents his death. The black disk also derives from a literary source: the sixteenth-century Quechua text *Apu Inka Atahuallpaman*, an elegy to Atahualpa, another of the final leaders of the Inca Empire. The text describes a "sun that turns yellow then darkens." The bifurcation of the painting's circular form may again allude to violence, or to a horizon line, while the bright colors and dotted patterns relate to Andean textiles.

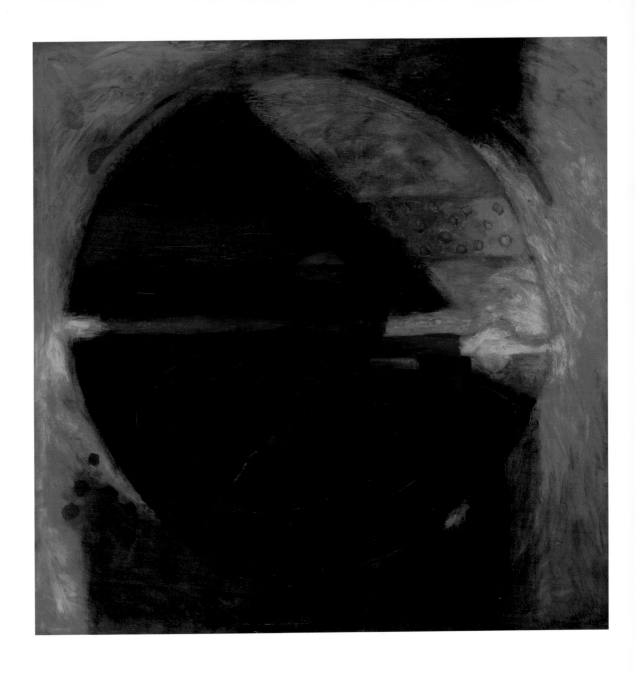

Nahum B. Zenil Mexican, b. 1947

Viva Libertad

1986
Mixed media on paper
19¾ × 26⅛ × 1¼ in.
Gift of Jerry M. Lindzon,
2012.6.2
© Nahum Zenil

Nahum B. Zenil spent the first 20 years of his career as a teacher in Mexico City, creating art in his spare time. He gave up teaching in 1984 and quickly became one of the most significant figures associated with Neo-Mexicanism. Zenil's works frequently explore his own identity and are permeated with national symbols and religious iconography.

Viva Libertad, a double self-portrait, is presented on sepia-toned paper that has been treated to suggest age. On the left, a figure representing Zenil wears a black, collared shirt with red, white, and green buttons, the colors of the Mexican flag. Over the chest pockets are mirror images of a pierced heart—one red and the other a black silhouette—a reference to the Catholic image of the Sacred Heart of Jesus, a symbol of Christ's suffering and a recurrent motif in Zenil's work. A miniature portrait peeks out of one pocket, while out of the other emerges a leafy plant—pierced with nails and decorated with red, white, and green ribbons—that encircles the artist's head like a halo. The vine further extends to form a canopy over a second self-portrait, depicted on a *trompe l'oeil* scrap of paper, to which the black-clad figure also points with his finger. In this vignette, ropes bind the artist's naked torso as he brandishes the Mexican flag, partially covering his face.

The ties binding Zenil's body may refer to the suffering and constriction experienced by the artist as a homosexual male living in a conservative, Catholic society. In lieu of the motto "Viva México," or "Long Live Mexico," as inscribed on the pictured flag, the title of the drawing instead declares "Long Live Liberty," perhaps a demand for personal as well as political freedom.

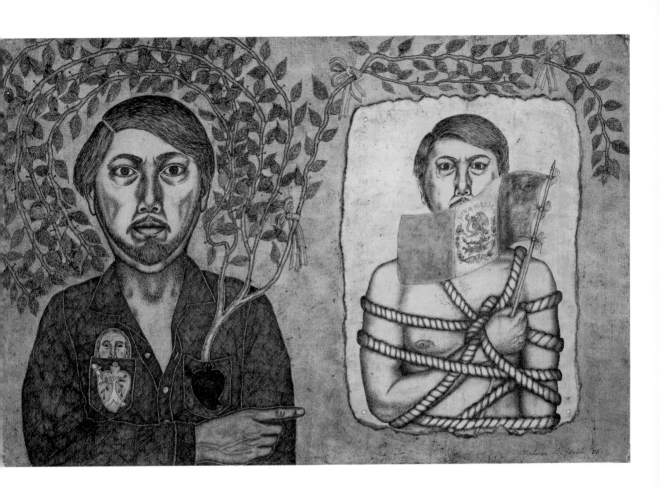

Collection Checklist

Carlos Alfonzo
CUBAN, 1950–1991

Untitled, 1988
Gouache and watercolor on heavy-weight
wove paper
Gift of Cristina Delgado (OC 1980) and
Stephen F. Olsen (OC 1979), 1995.18.1

Untitled, 1988
Gouache and watercolor on heavy-weight
wove paper
Gift of Cristina Delgado (OC 1980) and
Stephen F. Olsen (OC 1979), 1995.18.2

Manuel Álvarez Bravo
MEXICAN, 1902–2002

El Ensueño (The Daydream), 1931, printed
later
Gelatin silver print
Gift of Kenneth (OC 1967) and Nancy
Schwartz, from the collection of Gary
Schwartz (OC 1962), 2013.39

assume vivid astro focus (avaf)

Garden 3, 2002–03
Wallpaper installation on CD
Gift of Jerry M. Lindzon, 2012.6.7

Sinister Smile and Pasta, 2004
Print on Plexiglas
Gift of Jerry M. Lindzon, 2012.6.8

Carla and Skull, 2004
Print on Plexiglas
Gift of Jerry M. Lindzon, 2012.6.9

Graffiti LA 1, 2004
Print on Plexiglas
Gift of Jerry M. Lindzon, 2012.6.10.1

Graffiti LA 1, 2004
Decal on CD
Gift of Jerry M. Lindzon, 2012.6.10.2

Graffiti LA 4, 2004
Print on Plexiglas
Gift of Jerry M. Lindzon, 2012.6.11.1

Graffiti LA 4, 2004
Decal on CD
Gift of Jerry M. Lindzon, 2012.6.11.2

Ashtray, 2004
Decal on CD
Gift of Jerry M. Lindzon, 2012.6.12

Pills & Cigarettes, 2004
DVD
Gift of Jerry M. Lindzon, 2012.6.13

Luis Cruz Azaceta
CUBAN, b. 1942

The Journey, 1988
Acrylic on paper
Gift of Cristina Delgado (OC 1980) and
Stephen F. Olsen (OC 1979), 2000.23

José Bedia
CUBAN, b. 1959

Con Licencia, 1991
Ink on amate paper
Gift of Cristina Delgado (OC 1980) and
Stephen F. Olsen (OC 1979), 2011.14.4

Hugo Brehme
GERMAN, ACTIVE IN MEXICO,
1882–1954

Sepia-toned gelatin silver prints (84),
1905–25
Allen Memorial Art Museum, 2013.2–85
Aztec Calendar, Museo Nacional, 2013.7.2
Mayan Goddess, Museo Nacional, 2013.7.3
Puebla, 2013.7.4
Sacrificial Stone, Museo Nacional, 2013.7.5
Panorama of Puebla, 2013.7.6
Casa del Alfeñique, Puebla, 2013.7.7
Santo Domingo, El Rosario, Puebla,
2013.7.8
San Francisco, Acatepec, Puebla, 2013.7.9
Santo Domingo, Puebla, 2013.7.10

Santo Domingo, Oaxaca, 2013.7.11
Mitla Ruins, Oaxaca, 2013.7.12
Mitla Ruins, Oaxaca, 2013.7.13
Mitla Ruins, Oaxaca, 2013.7.14
Chichén Itzá Ruins, Yucatán, 2013.7.15
Chichén Itzá Ruins, Yucatán, 2013.7.16
Chichén Itzá Ruins, Yucatán, 2013.7.17
Chichén Itzá Ruins, Yucatán, 2013.7.18
Chalchicomula, Pico de Orizaba, 2013.7.19
Pico de Orizaba, 2013.7.20
Popocatépetl, Cholula, 2013.7.21
Pyramid, Cholula, 2013.7.22
Iztaccíhuatl, Cholula, 2013.7.23
Parish Church, Taxco, Guerrero, 2013.7.24
Parish Church, Taxco, Guerrero, 2013.7.25
Parish Church, Taxco, Guerrero, 2013.7.26
Parish Church Towers, Taxco, Guerrero,
2013.7.27
Dome of the Parish Church, Taxco, Guerrero,
2013.7.28
Taxco, Guerrero, 2013.7.29
Parish Church, Taxco, 2013.7.30
Parish Church Altar, Taxco, Guerrero,
2013.7.31
Teotihuacan, 2013.7.32
Pyramid of the Moon, Teotihuacan,
2013.7.33
Pyramid, Teotihuacan, 2013.7.34
Toltec Festival, Teotihuacan, 2013.7.35
Pyramid, Teotihuacan, 2013.7.36
Tepoztlán, Morelos, 2013.7.37
Palace of Cortés, Cuernavaca, Morelos,
2013.7.38
Tepoztlán, Morelos, 2013.7.39
Tepotzotlán, 2013.7.40
Tepotzotlán, 2013.7.41
Tepotzotlán, 2013.7.42
Tepotzotlán, 2013.7.43

Tepotzotlán, 2013.7.44

Tepotzotlán, 2013.7.45

Dome, Tepotzotlán, 2013.7.46

Typical Street, Orizaba, 2013.7.47

La Merced, 2013.7.48

Ocotlán Collegiate Church, Tlaxcala, 2013.7.49

Lacquerware, 2013.7.50

Churubusco, 2013.7.51

Convent of Guadalupe, Zacatecas, 2013.7.52

Iztaccíhuatl, Amecameca, 2013.7.53

Veracruz, 2013.7.54

The Cathedral, 2013.7.55

Side Chapel, Cathedral, 2013.7.56

Cuernavaca Cathedral, 2013.7.57

Iztaccíhuatl, 2013.7.58

El Pocito, La Villa, 2013.7.59

Fountain of Don Quixote, Chapultepec, 2013.7.60

Palace, Querétaro, 2013.7.61

Popocatépetl, Acatepec, 2013.7.62

Actopan, Hidalgo, 2013.7.63

Aqueduct, Los Remedios, 2013.7.64

Acolman, 2013.7.65

Pyramid, Teotihuacan, 2013.7.66

Teotihuacan, 2013.7.67

El Carmen, San Ángel, 2013.7.68

Cuicatlan, Oaxaca, 2013.7.69

Taxco, Guerrero, 2013.7.70

Sanctuary of Ocotlán, Tlaxcala, 2013.7.71

Sanctuary of Ocotlán, Tlaxcala, 2013.7.72

Cholula Pyramid, 2013.7.73

Puebla Cathedral, 2013.7.74

Puebla Cathedral, 2013.7.75

San Luis Potosí, Cathedral, 2013.7.76

Chihuahua Cathedral, 2013.7.77

Convent of Guadalupe, Zacatecas, 2013.7.78

Xochicalco Ruins, Guerrero, 2013.7.79

Morelia Cathedral, 2013.7.80

Acatepec, 2013.7.81

Tepoztlán, Morelos, 2013.7.82

San Francisco, Acatepec, 2013.7.83

Mitla Ruins, Oaxaca, 2013.7.84

Teotihuacan, 2013.7.85

Margarita Cabrera
MEXICAN, b. 1973

Bicicleta azul platino (Platinum Blue Bicycle), 2006
Vinyl, foam, string, and wire
Gift of Michael (OC 1964) and Driek
(OC 1965) Zirinsky in honor of bicyclists in
the Oberlin College class of 1964, 2013.48.6

Carlos Capelán
URUGUAYAN, b. 1948

Untitled (Hand), 1991
India ink, earth, and red ochre on
Scandinavian map
Gift of Cristina Delgado (OC 1980) and
Stephen F. Olsen (OC 1979), 1997.37.1

Untitled (Male), 1992
India ink and earth on nautical charts
Gift of Jerry M. Lindzon, 2012.6.3

Untitled (Female), 1992
India ink and earth on nautical charts
Gift of Jerry M. Lindzon, 2012.6.4

Rimer Cardillo
URUGUAYAN, b. 1944

Silent Barrack, 1989
Wood, paper, pastel, graphite, metal, dirt,
and gravel
Gift of Cristina Delgado (OC 1980) and
Stephen F. Olsen (OC 1979), 1995.14.1A–E

Untitled, from the series *Vanishing Tapestries*, 1996
Photo-silkscreen on canvas
Gift of Cristina Delgado (OC 1980) and
Stephen F. Olsen (OC 1979), 1997.37.4

Consuelo Castañeda
CUBAN, b. 1958

Untitled, from the series *Speed-Split*, 1998
Digital photographs
Gift of Cristina Delgado (OC 1980) and
Stephen F. Olsen (OC 1979), 2012.24 A–D

Enrique Chagoya
MEXICAN, b. 1953

*Codex Espangliensis: From Columbus to
the Border Patrol*, 1998
Ink and color on amate paper
Gift of Michael (OC 1964) and Driek
(OC 1965) Zirinsky in honor of Frederick B.
Artz, 2013.38
Illustrator: Enrique Chagoya (Mexican,
b. 1953)
Author: Guillermo Gómez-Peña (Mexican,
b. 1955)
Printer: Felicia Rice (American, b. 1954)
Publisher: Moving Parts Press, Santa
Cruz, CA

Elvis Meets the Virgin of Guadalupe, 1994
Color lithograph
Gift of Michael (OC 1964) and Driek
(OC 1965) Zirinsky, 2013.48.3

Das Tausendjährige Reich, 1995
Acrylic and oil on amate paper
Gift of Michael (OC 1964) and Driek
(OC 1965) Zirinsky, 2013.48.4

Jean Charlot
**AMERICAN, BORN IN FRANCE,
ACTIVE IN MEXICO, 1898–1979**

Mother and Child, 1941
Color lithograph
Mrs. F. F. Prentiss Fund, 1945.3

Picture Book II, 1973
Book and offset color lithograph
Gift of Jack Lord, 1973.97

Miguel Covarrubias
MEXICAN, 1904–1957

Bohème, ca. 1929
Brush, ink, and heightening
Gift of Mrs. Malcolm L. McBride, 1945.137

Juan Downey
CHILEAN, 1940–1993

J. S. Bach, from the series *The Thinking Eye*,
1986
Color video with sound
Gift of Cristina Delgado (OC 1980) and
Stephen F. Olsen (OC 1979), 2013.11.2

Edouard Duval-Carrié
HAITIAN, b. 1954

Justicia, 1998
Oil on canvas with aluminum frame
Gift of Jerry M. Lindzon, 2012.6.6

Marisol Escobar
AMERICAN, BORN IN FRANCE, 1930

Five Hands and One Finger, 1971
Lithograph
Fund for Contemporary Art, 1974.17

Tomás Esson
CUBAN, b. 1963

Untitled, 1996
Color etching
Gift of Cristina Delgado (OC 1980) and
Stephen F. Olsen (OC 1979), 1997.37.5

Antonio Frasconi
ARGENTINE, 1919–2013

The Dog and the Crocodile, from *Some Well-
Known Fables*, 1950
Woodcut
Gift of the Print Club of Cleveland, 1952.87

The Storm is Coming, 1950
Color woodcut
Gift of Robert M. Light in memory of his
parents, Freeman and Ara Light, 1972.5

Ismael Frigerio
CHILEAN, b. 1955

Laughing Flames III, 1990
Tempera and acrylic on canvas
Gift of Cristina Delgado (OC 1980) and
Stephen F. Olsen (OC 1979), 1995.14.2

Sacred Blood, 1990
Serigraph
Gift of Cristina Delgado (OC 1980) and
Stephen F. Olsen (OC 1979), 1997.37.2

Study for Lust of Conquest, 1984–85
Watercolor, graphite, and colored pencil
Gift of Cristina Delgado (OC 1980) and
Stephen F. Olsen (OC 1979), 2013.62.3

Landscape with Fish, 1984
Watercolor, graphite, and colored pencil
Gift of Cristina Delgado (OC 1980) and
Stephen F. Olsen (OC 1979), 2013.62.4

Carlos Garaicoa
CUBAN, b. 1967

*Windmills; Because Every City Has the Right
To Be Called Utopia*, 2001
Pins and thread
Gift of Cristina Delgado (OC 1980) and
Stephen F. Olsen (OC 1979), Dolores Del-
gado, Elena Delgado, and William Hilton,
2010.9

Rupert García
AMERICAN, b. 1941

The First of May, from the *Corcoran 2005
Print Portfolio: Drawn to Representation*,
2004
Drypoint and aquatint
Gift of Anna Leithauser (OC 2002),
2006.35.7

Felix Gonzalez-Torres
CUBAN, 1957–1996

Untitled (Death by Gun), 1991
Offset print on paper
Ellen H. Johnson Bequest, 1998.7.35

Untitled (Oscar Wilde), 1995
Photo etching
Gift of Cristina Delgado (OC 1980) and
Stephen F. Olsen (OC 1979), 2013.5

Quisqueya Henríquez
CUBAN, b. 1966

Two Skins, 1995
Mixed media installation
Gift of Jerry M. Lindzon, 2012.6.5 A–B

Alfredo Jaar
CHILEAN, b. 1956

Untitled, from the portfolio *In a Dream You
Saw a Way to Survive and You Were Full of
Joy*, 1990
Laminated Duratrans transparency, fluores-
cent light box
Horace W. Goldsmith Foundation Photogra-
phy Fund, 1991.35.4

Terra Non Descoperta (Undiscovered Land),
1991
Light box and color transparency
Gift of Cristina Delgado (OC 1980) and
Stephen F. Olsen (OC 1979), 2004.13.2

Church, from the project *Real Pictures*,
1994–95
Cibachrome print housed in a black linen
archive box with silkscreened text
Gift of Cristina Delgado (OC 1980) and
Stephen F. Olsen (OC 1979), 2004.13.3 A–B

Camp, from the project *Real Pictures*,
1994–95
Cibachrome print housed in a black linen
archive box with silkscreened text
Gift of Cristina Delgado (OC 1980) and
Stephen F. Olsen (OC 1979), 2004.13.4 A–B

Couple, from the project *Real Pictures*,
1994–95
Cibachrome print housed in a black linen
archive box with silkscreened text
Gift of Cristina Delgado (OC 1980) and
Stephen F. Olsen (OC 1979), 2004.13.5 A–B

The Body is the Map, 1990
Nine Cibachrome prints
Gift of Jerry M. Lindzon, 2012.6.1 A–I

Luis Jiménez
AMERICAN, 1940–2006

Vaquero, 1981
Six-color lithograph with applied glitter on
Arjomari paper
Gift of Allan Frumkin, 1982.70

Jac Leirner
BRAZILIAN, b. 1961

Little Blue Phase, 1991
Brazilian bank notes, polyurethane cord,
and Plexiglas
Gift of Jerry M. Lindzon, 2010.25.1

Prize (Corpus delicti), 1993
Airline ashtrays, boarding passes and airline
tickets; metal stand; Plexiglas
Gift of Jerry M. Lindzon, 2010.25.2

Francisco Mata Rosas
MEXICAN, b. 1958

Mictlán, from the series *México Tenochti-
tlán*, 1997
Gelatin silver print
Ruth C. Roush Contemporary Art Fund,
2013.10

Matta
CHILEAN, 1911–2002

Untitled, from the series *Cosmicstrip*, 1959
Etching and aquatint
Gift of Kenneth and Barbara Watson,
2009.25.24

Untitled, 1948
Gouache and crayon on paper
Gift of Kenneth and Barbara Watson,
2009.25.45

Untitled, from *Come detta dentro vo
significado*, 1962
Etching and aquatint
Gift of Kenneth and Barbara Watson,
2009.25.50

Untitled, from *Come detta dentro vo
significado*, 1962
Etching and aquatint
Gift of Kenneth and Barbara Watson,
2009.25.51

Untitled, 1968
Color etching and aquatint with hand
touching
Gift of Allan and Jean Frumkin, 2011.29

Wild West, 1962
Pencil and colored crayons
Gift of Allan and Jean Frumkin, 2013.67.1

Wild West, ca. 1962
Pencil and colored crayons
Gift of Allan and Jean Frumkin, 2013.67.2

Wild West, 1962
Pencil and colored crayons
Gift of Allan and Jean Frumkin, 2013.67.3

Wild West (Two Men on Horseback), 1962
Pencil and colored crayons
Gift of Allan and Jean Frumkin, 2013.67.4

Seven Figures, ca. 1962
Pencil and colored crayons
Gift of Allan and Jean Frumkin, 2013.67.5

Ana Mendieta
AMERICAN, BORN IN CUBA, 1948–1985

Untitled, 1981–84
Wash on paper
Oberlin Friends of Art Fund and Ruth C.
Roush Fund for Contemporary Art, 1995.20

Untitled (Guanaroca [First Woman]), 1981,
printed in 1994
Gelatin silver print
Gift of Cristina Delgado (OC 1980) and
Stephen F. Olsen (OC 1979), 2011.14.1

Body Tracks, 1974
Suite of five chromogenic prints
Gift of Cristina Delgado (OC 1980) and
Stephen F. Olsen (OC 1979), 2011.14.2

Body Tracks, 1974
Suite of five chromogenic prints
Gift of Cristina Delgado (OC 1980) and
Stephen F. Olsen (OC 1979), 2011.14.3

Raquelín Mendieta
AMERICAN, BORN IN CUBA, 1946

KalyAni, 1989
Paper, dried leaves, and flowers with graphite and felt-tip pen on marbled paper
Gift of Cristina Delgado (OC 1980) and Stephen F. Olsen (OC 1979), 1997.37.3

Cildo Meireles
BRAZILIAN, b. 1948

Zero Dollar, 1978–84
Offset lithograph
Gift of Cristina Delgado (OC 1980) and Stephen F. Olsen (OC 1979), 2013.62.1

Carlos Mérida
GUATEMALAN, ACTIVE IN MEXICO, 1891–1984

Untitled, 1934
Lithograph
Gift of Katharine Kuh, 1978.37.1

Untitled, 1934
Lithograph
Gift of Katharine Kuh, 1978.37.2

Untitled, 1934
Lithograph
Gift of Katharine Kuh, 1978.37.3

Untitled, 1934
Lithograph
Gift of Katharine Kuh, 1978.37.4

Guillermo Meza
MEXICAN, 1917–1997

Nopalera, 1946
Oil on paper
Charles F. Olney Fund, 1947.29

Raul Milian
CUBAN, 1914–1986

Composition, 1952
Ink and wash
Gift of Joseph Cantor through the Smithsonian Institution, 1956.8

Vik Muniz
BRAZILIAN, b. 1961

Valicia Bathes in Sunday Clothes, from the series *Sugar Children*, 1996
Gelatin silver print
Gift of Anne and Joel Ehrenkranz, 2013.68.5

Untitled (Medusa Plate), for the *Peter Norton Family Christmas Project*, 1999
Photographic transfer-printed porcelain plate
Gift of Anne and Joel Ehrenkranz, 2013.68.14

Ernesto Neto
BRAZILIAN, b. 1964

Untitled, 1995
Construction paper, black thread, wax, and lead
Gift of Cristina Delgado (OC 1980) and Stephen F. Olsen (OC 1979), 2004.13.6

Gabriel Orozco
MEXICAN, b. 1962

Pelota en el agua (Ball on Water), 1994
Silver dye bleach print
Gift of Cristina Delgado (OC 1980) and Stephen F. Olsen (OC 1979), 2002.21.2

Extensión del reflejo (Extension of Reflection), 1992
Silver dye bleach print
Gift of Cristina Delgado (OC 1980) and Stephen F. Olsen (OC 1979), 2002.21.3

Ex-vitral, 2000
Silver dye bleach print
Gift of Cristina Delgado (OC 1980) and Stephen F. Olsen (OC 1979), 2002.21.4

Venado (Deer), 1993
Silver dye bleach print
Gift of Cristina Delgado (OC 1980) and Stephen F. Olsen (OC 1979), 2002.21.5

Love Affair, 2000
Silver dye bleach print
Gift of Cristina Delgado (OC 1980) and Stephen F. Olsen (OC 1979), 2013.62.5

Lemon Distance Call, 2000
Silver dye bleach print
Gift of Cristina Delgado (OC 1980) and Stephen F. Olsen (OC 1979), 2013.62.6

José Clemente Orozco
MEXICAN, 1883–1949

Negroes, from the series *The American Scene No. 1*, 1933
Lithograph
Museum Purchase, 1936.9

Mexican House, 1929
Oil on canvas
Gift of Mrs. Malcolm L. McBride, 1943.273

Three Generations, 1926
Lithograph
Gift of Leona E. Prasse from the Mr. and Mrs. Charles G. Prasse Collection in honor of Ellen H. Johnson, 1977.89

La Bandera (The Flag), 1928
Lithograph
Gift of Leona E. Prasse from the Mr. and Mrs. Charles G. Prasse Collection in honor of Ellen H. Johnson, 1977.90

Casa arruinada (Ruined House), 1928
Lithograph
Gift of Leona E. Prasse from the Mr. and Mrs. Charles G. Prasse Collection in honor of Ellen H. Johnson, 1977.91

Marching Women, 1928
Lithograph
Gift of Leona E. Prasse from the Mr. and Mrs. Charles G. Prasse Collection in honor of Ellen H. Johnson, 1977.92

La Retaguardia (Rear Guard), 1929
Lithograph
Gift of Leona E. Prasse from the Mr. and Mrs. Charles G. Prasse Collection in honor of Ellen H. Johnson, 1978.48

Paisaje mexicana (Mexican Landscape), 1930
Lithograph
Gift of Leona E. Prasse from the Mr. and Mrs. Charles G. Prasse Collection in honor of Ellen H. Johnson, 1978.49

Carlos Orozco Romero
MEXICAN, 1898–1984

Head, 1932
Oil on canvas
Gift of Mrs. Malcolm L. McBride, 1945.139

Pepón Osorio
AMERICAN, BORN IN PUERTO RICO, 1955

Tina's House, from the series *Home Visits*, 2000
Mixed media
Gift of Esther S. Weissman, 2003.16

Adolfo Patiño Torres
MEXICAN, 1954–2005

Triángulo místico, 1983
Cut rulers, paper cutouts, wood, paint, and acrylic
Gift of Edward J. Sullivan in honor of Denise Birkhofer, 2013.28

Mauro Piva
BRAZILIAN, b. 1977

Untitled, 2000
Nankeen and watercolor on paper
Gift of Cristina Delgado (OC 1980) and Stephen F. Olsen (OC 1979), 2013.62.7

Untitled, 2000
Nankeen and watercolor on paper
Gift of Cristina Delgado (OC 1980) and Stephen F. Olsen (OC 1979), 2013.62.8

Untitled, 2000
Nankeen and watercolor on paper
Gift of Cristina Delgado (OC 1980) and Stephen F. Olsen (OC 1979), 2013.62.9

Untitled, 2000
Nankeen and watercolor on paper
Gift of Cristina Delgado (OC 1980) and Stephen F. Olsen (OC 1979), 2013.62.10

Liliana Porter
ARGENTINE, b. 1941

Wrinkle, 1968
Photo-etching
Anonymous Gift, 1985.37

Brancusi, 2008
Duraflex photograph
Ruth C. Roush Contemporary Art Fund,
2013.4

René Portocarrero
CUBAN, 1912–1985

Señales No. 2, 1952
Tempera and ink
Gift of Mr. Joseph Cantor, 1956.7

Jesus "Chucho" Reyes Ferreira
MEXICAN, 1880–1977

Clown, ca. 1940
Tempera, tissue paper
Gift of Mrs. Malcolm L. McBride, 1946.53

Miguel Rio Branco
BRAZILIAN, b. 1946

Galo de Briga, 1984
Cibachrome print
Gift of Cristina Delgado (OC 1980) and
Stephen F. Olsen (OC 1979), 2013.62.2

Diego Rivera
MEXICAN, 1886–1957

Self-Portrait, 1930
Lithograph
Gift of Mrs. Malcolm L. McBride, 1941.29

Portrait of a Girl, ca. 1945
Watercolor
Charles F. Olney Fund, 1947.30

Emiliano Zapata, 1932
Lithograph
Gift of Leona E. Prasse from the Mr. and
Mrs. Charles G. Prasse Collection in honor
of Ellen H. Johnson, 1977.93

Young Boy Eating, 1932
Lithograph
Gift of Leona E. Prasse from the Mr. and
Mrs. Charles G. Prasse Collection in honor
of Ellen H. Johnson, 1977.94

Open-Air School, 1932
Lithograph
Gift of Leona E. Prasse from the Mr. and
Mrs. Charles G. Prasse Collection in honor
of Ellen H. Johnson, 1977.95

The Fruits of Labor, 1932
Lithograph
Gift of Leona E. Prasse from the Mr. and
Mrs. Charles G. Prasse Collection in honor
of Ellen H. Johnson, 1978.50

Arnaldo Roche-Rabell
PUERTO RICAN, b. 1955

Man in the Dark, 1989
Oil on paper
Gift of Cristina Delgado (OC 1980) and
Stephen F. Olsen (OC 1979), 1995.14.5

Artemio Rodriguez
MEXICAN, b. 1972

The Triumph of Death, 2007
Woodcut in nine panels
Gift of Michael (OC 1964) and Driek
(OC 1965) Zirinsky, 2013.48.1A–I

*One God, One City, One Woman (Beauty Is
Not Always Perfect)*, 2002
Woodcut
Gift of Michael (OC 1964) and Driek
(OC 1965) Zirinsky, 2013.48.2

Doris Salcedo
COLOMBIAN, b. 1958

Untitled, 1989–93
Shirts, gesso, and steel rebars
Gift of Cristina Delgado (OC 1980) and
Stephen F. Olsen (OC 1979), 2002.21.1

René Santos
PUERTO RICAN, 1954–1986

Harp Drawing, 1983
Colored pencil, grease pencil overlay
Friends of Art Endowment Fund, 1983.129

Andres Serrano
AMERICAN, b. 1950

Untitled VII (Ejaculate in Trajectory), 1989
Cibachrome print
Ruth C. Roush Contemporary Art Fund,
1989.10

Blood and Semen V, from the portfolio
*In a Dream You Saw a Way to Survive and
You Were Full of Joy*, 1990
Silver dye bleach print
Horace W. Goldsmith Foundation Photography Fund, 1991.35.8

Klansman (Knighthawk of Georgia, V), 1990
Cibachrome print
Art Rental Collection Transfer, 2009.9

David Alfaro Siqueiros
MEXICAN, 1896–1974

Portrait, 1937
Lithograph
Gift of Leona E. Prasse in honor of Hazel B.
King, 1953.269

Máscara (Mask), from the series *Mountain
Suite*, 1969
Color lithograph
Gift of Thomas G. Campbell (OC 1955),
1974.74

Niña madre (Child Mother), 1956
Lithograph
Gift of Mr. and Mrs. Paul Seligson in honor
of their daughter, Judy Seligson (OC 1981),
1977.78

Emiliano Zapata, 1926
Lithograph
Gift of Leona E. Prasse from the Mr. and
Mrs. Charles G. Prasse Collection in honor
of Ellen H. Johnson, 1978.51

Fernando de Szyszlo
PERUVIAN, b. 1925

The Execution of Túpac Amaru, 1966
Oil on canvas
Gift of Norman and Jean Moore (OC 1938),
2007.25

Francisco Toledo
MEXICAN, b. 1940

*Durero con sapo y chapulin (Dürer with
Grasshoppers and Toad)*, 1999
Mezzotint
Gift of Michael (OC 1964) and Driek
(OC 1965) Zirinsky, 2013.48.5

César Trasobares
CUBAN, b. 1949

Upon, 1997
Mixed media with watch and humidity
control chart
Gift of the artist, 1997.44

Nahum B. Zenil
MEXICAN, b. 1947

Viva Libertad, 1986
Mixed media on paper
Gift of Jerry M. Lindzon, 2012.6.2

Sources

pp. 30–31: assume vivid astro focus, Cay Sophie Rabinowitz, and Natalie Kovacz. *assume vivid astro focus*. New York: Rizzoli, 2010. Exhibition catalogue.

p. 32: Luis Cruz Azaceta and Friedhelm Mennekes. "Luis Cruz Azaceta: Interview with Friedhelm Mennekes." In *Luis Cruz Azaceta*, edited by Gerard A. Goodrow, 9–13. New York: Frumkin / Adams Gallery, 1988. Exhibition catalogue.

p. 34: Melissa E. Feldman. "Blood Relations: José Bedia, Joseph Beuys, David Hammons, and Ana Mendieta." In *Reclaiming the Spiritual in Art: Contemporary Cross-Cultural Perspectives*, edited by Debra Koppman and Dawn Perlmutter, 105–16. Albany, NY: State University of New York Press, 1999.

pp. 36–37: Stella de Sá Rego. "Hugo Brehme, Maker of Mythologies." In *Timeless Mexico: The Photographs of Hugo Brehme*, by Hugo Brehme and Susan Toomey Frost, 14–21. Austin, TX: University of Texas Press, 2011.

p. 40: Lucy R. Lippard. "Contact Zones: Travel and Archaeology in the Work of Rimer Cardillo." In *Rimer Cardillo: Araucaria*, by Rimer Cardillo, Lucy R. Lippard, Marysol Nieves, and Patricia C. Phillips, 29–33. Bronx, NY: Bronx Museum of the Arts, 1998. Exhibition catalogue.

Marysol Nieves. "Vanishing Histories: Rimer Cardillo and the Aesthetics of Reclamation and Renewal." In *Rimer Cardillo: Araucaria*. By Rimer Cardillo, Lucy R. Lippard, Marysol Nieves, and Patricia C. Phillips, 9–27. Bronx, NY: Bronx Museum of the Arts, 1998. Exhibition catalogue.

p. 42: Patricia Hickson, ed. *Enrique Chagoya: Borderlandia*. Des Moines, IA: Des Moines Art Center, 2007. Exhibition catalogue.

p. 50: *Quisqueya Henríquez: The World Outside, A Survey Exhibition 1991–2007*. New York: Bronx Museum of the Arts, 2007. Exhibition catalogue.

pp. 52–55: Debra Bricker Balken and Alfredo Jaar. *Alfredo Jaar: Lament of the Images*. Cambridge, MA: MIT List Visual Arts Center, 1999. Exhibition catalogue.

Rick Pirro. "Pictures, Politics, and the Work of Alfredo Jaar." In *It is Difficult: Ten Years*, by Alfredo Jaar (not paginated). Barcelona: Actar, 1998. Exhibition catalogue.

p. 56: Adele Nelson and Jac Leirner. *Jac Leirner in Conversation with Adele Nelson (Jac Leirner en conversación con Adele Nelson)*. New York: Fundación Cisneros / Colección Patricia Phelps de Cisneros, in cooperation with North America Distributed Art Publishers, 2011.

p. 58: Francisco Mata Rosas. "Statement." *México Tenochtitlán*. http://www.zonezero.com/exposiciones/fotografos/matafco/index.html.

pp. 60–62: Claude Cernuschi. "Mindscapes and Mind Games: Visualizing Thought in the Work of Matta and his Abstract Expressionist Contemporaries." In *Matta: Making the Invisible Visible*, edited by Elizabeth T. Goizueta, 48–80. Chestnut Hill, MA: McMullen Museum of Art, Boston College, in cooperation with the University of Chicago Press, 2004. Exhibition catalogue.

Roberto Sebastián Matta Echaurren. *Matta: Works from Chicago Collections*. Chicago: The Arts Club of Chicago, 1993. Exhibition catalogue.

Roberto Sebastián Matta Echaurren and Roland Sabatier. *Matta: Catalogue raisonné de l'oeuvre gravé (1943–1974)*. Stockholm: Sonet, 1975.

Gloria Beatriz McDowell. "The Space of the Species: Matta's 'Sensitive Mathematics — Architecture of Time' and Surrealism in its Third Phase." Master's thesis, University of Oregon, 2002.

pp. 64–65: Ana Mendieta and Abigail Solomon-Godeau. *Ana Mendieta: Blood & Fire*. Paris; New York: Galerie Lelong, 2011.

p. 66: Courtney Gilbert. "Carlos Mérida." In *Blanton Museum of Art Latin American Collection*, edited by Gabriel Pérez-Barreiro, 276–79. Austin, TX: Blanton Museum of Art, 2006.

p. 70: Mark Magill. "Interview with Vik Muniz." *Bomb* 73 (Fall 2000). http://bombsite.com/issues/73/articles/2333

p. 74: Mia Finerman, Gabriel Orozco, and Phyllis D. Rosenzweig. *Gabriel Orozco: Photographs*. Washington, DC: Hirshhorn Museum and Sculpture Garden, Smithsonian Museum, 2004. Exhibition catalogue.

Ann Temkin. "Open Studio." In *Gabriel Orozco*, by Gabriel Orozco and Ann Temkin, 10–21. New York: Museum of Modern Art, 2009. Exhibition catalogue.

p. 76: Anna Indych. "Made for the USA: Orozco's *Horrores de la Revolución*." *Anales del Instituto de Investigaciones Estéticas* 23, no. 79 (2001): 153–164.

pp. 78–79: *Art:21, Place*. Public Broadcasting System, September 21, 2001. http://video.pbs.org/video/1230660017/. Video.

p. 80: Denise Birkhofer. *On and Off the Streets: Photography and Performance in Mexico City, 1974–84*. Ph.D. diss., The Institute of Fine Arts, New York University, 2013.

Teresa Eckmann. *Neo-Mexicanism: Mexican Figurative Painting and Patronage in the 1980s*. Albuquerque, NM: University of New Mexico Press, 2010.

p. 82: Florencia Bazzano-Nelson. *Liliana Porter and the Art of Simulation*. Burlington, VT: Ashgate Publishing, 2008.

Edward J. Sullivan. *The Language of Objects in the Art of the Americas*. New Haven, CT: Yale University Press, 2007.

p. 84: Ramón Vázquez Díaz, Graziella Pogolotti, and René Portocarrero. *René Portocarrero*. Berlin: Henschel; La Habana: Letras Cubanas, 1987.

p. 92: Artemio Rodriguez. "Artemio Rodriguez, *Triumph of Death*." In "Continuing Lines: Jean Charlot, Paul Mullowney, Artemio Rodriguez, September 7–October 19, 2008." Schaefer International Gallery, Maui Arts and Cultural Center. http://www.mauiarts.org/schaefer/ContinungLinesOneSheet.pdf

p. 96: Denise Birkhofer. "Trace Memories: Clothing as Metaphor in the Work of Doris Salcedo." *Anamesa* 6, no. 1 (Spring 2008): 48–67.

Charles Merewether. "Naming Violence in the Work of Doris Salcedo." *Third Text* 7, no. 24 (Autumn 1993): 35–44.

Doris Salcedo. "Traces of Memory: Art and Remembrance in Colombia." *ReVista: Harvard Review of Latin America* (Spring 2003): 28–30.

Edward J. Sullivan. *The Language of Objects in the Art of the Americas*. New Haven, CT: Yale University Press, 2007.

p. 98: Stephen Jost. In *Masterworks for Learning: A College Collection Catalogue*. Oberlin, OH: Allen Memorial Art Museum, Oberlin College, 1998. CD-ROM.

p. 102: Jacqueline Barnitz. "Fernando de Szyszlo." In *Blanton Museum of Art Latin American Collection*, edited by Gabriel Pérez-Barreiro, 390–94. Austin, TX: Blanton Museum of Art, 2006.

Jacqueline Barnitz. *Twentieth-Century Art of Latin America*. Austin, TX: University of Texas Press, 2001.

p. 104: Edward J. Sullivan. "Nahum B. Zenil: Witness to the Self / Testigo del ser." In *Nahum B. Zenil: Witness to the Self (Testigo del ser)*, by Clayton Kirking, Edward J. Sullivan, and Nahum Zenil, 9–17. San Francisco: The Mexican Museum, 1996. Exhibition catalogue.

Edward J. Sullivan. *The Language of Objects in the Art of the Americas*. New Haven, CT: Yale University Press, 2007.

Photography Credits

Dirk Bakker: pp. 10, 17, 43 (top), 51, 55 (left), 57, 73, 78–79, 81, 97, back cover; Selina Bartlett: pp. 24, 41 (top), 49 (bottom); Caixa Cultural, Rio de Janeiro: p. 49 (top); Cleveland Public Library Digital Gallery: p. 13; Patricia Conde Galería: p. 59; Mauro Restiffe: p. 31; and John Seyfried: front cover, pp. 2, 12, 14, 15, 16, 18, 19, 20, 22, 23, 26, 29, 30, 33, 35, 37–39, 41 (bottom), 43 (bottom), 45, 47, 53, 54, 55 (right), 61–63, 64–65, 67, 69, 71, 75, 77, 83, 85, 87, 88–89, 91, 93–95, 99, 100–101, 103, and 105.